IMAGES
*of America*

# NORTH ELBA AND
# WHITEFACE MOUNTAIN

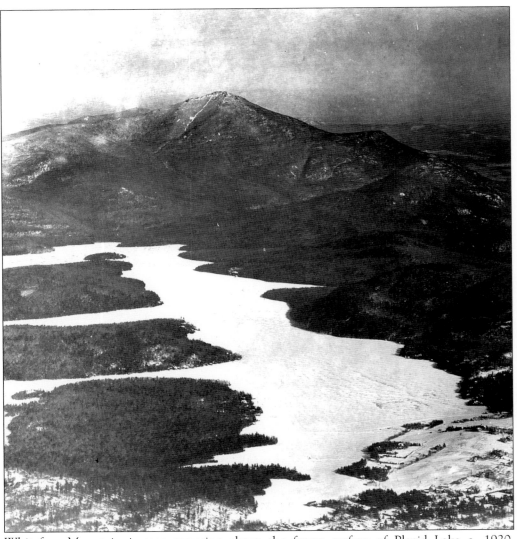

Whiteface Mountain is seen towering above the frozen surface of Placid Lake *c.* 1920. (Hamilton Maxwell Company, New York City.)

IMAGES
*of America*

# NORTH ELBA AND WHITEFACE MOUNTAIN

Dean S. Stansfield

ARCADIA

First printed in 2003.

Published by Arcadia Publishing,
an imprint of Tempus Publishing Inc.
2A Cumberland Street
Charleston, SC 29401

Printed in Great Britain.

Library of Congress Catalog Card Number: 2003107574.

For all general information, contact Arcadia Publishing:
Telephone 843-853-2070
Fax 843-853-0044
E-mail sales@arcadiapublishing.com

For customer service and orders:
Toll-free 1-888-313-2665

Visit us on the Internet at www.arcadiapublishing.com.

*I would like to dedicate this book to the late Mary MacKenzie, who was the town historian of North Elba and Lake Placid village for more than 38 years. Mary passed away on April 15, 2003. She was never too busy to meet with me and answer questions or offer help to identify photographs. She lived in Lake Placid all her life and will be missed by the many people she assisted and educated about the area throughout the years.*

A view through the trees shows some of the Southern Range high peaks c. 1935. (Photographer Roger Moore.)

# CONTENTS

# FOREWORD

"The Adirondack Mountains—once you get them in your blood, you can't leave." Many of the region's visitors and residents have found this old saying to be true. The high Adirondack peaks are as breathtaking when covered with snow in winter as with the lush greenery of summer. The lakes are at times so still and glassy that one can see a reflection. At other times, they become rough and tumultuous when the winds are strong. The area's natural beauty and recreational opportunities draw both casual vacationers and seasoned wilderness explorers who come to visit but often find excuses to stay.

The Adirondacks were first introduced to "skeeing" in the winter of 1904–1905, when Melvil Dewey, inventor of the Dewey decimal system, ordered snow skis from Norway for a small group of guests at the Lake Placid Club. The Adirondacks captured the world's attention when the 1932 and 1980 Olympics were held in the quaint village of Lake Placid. Athletes, visitors, and celebrities came to participate or to watch, but many stayed and built homes and camps. Numerous hotels, and later motels, were built to accommodate visitors from all over the world. Local, national, and world events were scheduled in every winter sport, including speed skating, figure skating, bobsledding, luge, cross-country and downhill skiing, and ski jumping. The pure air in the Adirondacks was found to be healing for those with breathing difficulties. Soon, cure homes and tuberculosis hospitals were opened. Despite the rugged geography and harsh weather, the Adirondacks grew rapidly in population because of the diverse recreational and medical opportunities.

In this book you will find many outstanding photographs showcasing the region's growth. The images display the breathtaking scenery, rustic camps, village buildings, hotels, and facilities that changed the quiet wilderness into a busy, modern-day vacation haven.

Beverley Reid
Historian
Town of North Elba
Village of Lake Placid

# INTRODUCTION

The town of North Elba was established in 1850 on land that had originally been part of the town of Keene in Essex County, New York. The town's people chose the name because there was already an Elba township in Genesee County. The first town post office was located in a roadside inn on the Old Military Road. In 1850, Joseph Nash bought 320 acres of land on the west shore of Bennett's Pond (later called Mirror Lake) so he could establish a farm. He built a house and outbuildings and became the first resident of what later became the village of Lake Placid. In 1851, Benjamin Brewster bought land on the northwest end of the pond and built another farmhouse. The village was off to a slow but steady start with two resident families.

North Elba township consists of 157 square miles of land. The town is made up of 76 percent "forever wild" Adirondack Park forestland, with the remaining 24 percent privately owned. The northwestern corner of the town lies within the village of Saranac Lake. The hamlet of Ray Brook is located a couple of miles to the east. Lake Placid village is approximately in the center of the township, with Placid Lake just to the north. The Cascade Lakes and Wilmington Notch lie slightly east of the town's eastern border. Whiteface Mountain sits at the northern end of Placid Lake in the town of Wilmington.

People began traveling through the northern Adirondack region in the 1850s to pursue recreational activities such as hunting, fishing, hiking, and mountain climbing. Many sought a comfortable place to spend the night, so North Elba residents built inns, and later hotels, to accommodate them. In 1871, Benjamin Brewster built the first real hotel in Lake Placid and called it the Lake Placid House. It proved to be so popular that other hotels were rapidly built in Lake Placid, the Cascade Lakes, Ray Brook, and Saranac Lake. By the 1890s, Lake Placid was one of the most popular summer vacation destinations in the Adirondack Mountains. When the railroad line from Saranac Lake to Lake Placid was built in 1893, New York City was only an overnight ride away by railroad coach.

Ice-skating became popular in Lake Placid before 1900, and in 1905, the Lake Placid Club brought cross-country skiing to the region. Ski jumping, curling, speed skating, skijoring, tobogganing, dogsledding, and figure skating soon followed. Lake Placid was host village for the 1932 and the 1980 Winter Olympic Games. These two events garnered the small village much worldwide fame. In 1950, Whiteface Mountain joined in the winter fun with a downhill ski center. For many years, Lake Placid was the winter sports capital of North America.

Let's use these photographs from the past to see what the North Elba and Whiteface Mountain region was like from the 1870s to 1940.

# ACKNOWLEDGMENTS

I would like to thank Beverley Reid, historian for the town of North Elba and the village of Lake Placid, for her hours of time helping me with Mary MacKenzie's photograph archives at the Lake Placid Library. She has also graciously answered many of my questions in the last few months. I would also like to thank the library, and my friend Peter J. Clark for letting me borrow photographs from their collections. Thanks are due also to John Bogle, Vincent Forrest, Lee Manchester, and Doug Wolfe for their help.

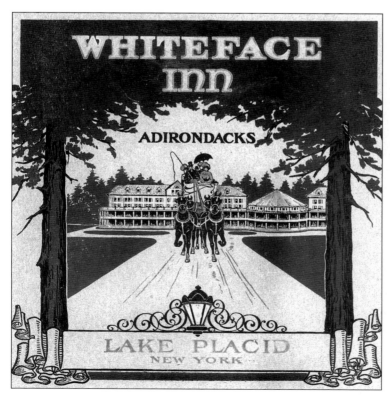

The Whiteface Inn used this cover illustration for a hotel brochure *c.* 1905.

# *One*
# LAKE PLACID VILLAGE

Merriam's Drug Store, located at 37 Main Street, is shown decorated for the 1914 Mid-Winter Festival. Local photographer G.T. Rabineau had a photography shop under the drugstore at this location in the 1920s. (Courtesy Mary MacKenzie.)

This *c.* 1890 panoramic view shows the northwest shore of Mirror Lake just past the start of Saranac Avenue. Joseph Nash's daughter Carrie built and ran the Lakeside Inn, a small hotel

Joseph Nash was a farmer who owned most of the west shore of today's Mirror Lake in 1855. He began taking in summer boarders and, in 1876, built the second hotel in what later became the village of Lake Placid. His only early neighbor on the lake was Martin Brewster, another farmer. (Courtesy Mary MacKenzie.)

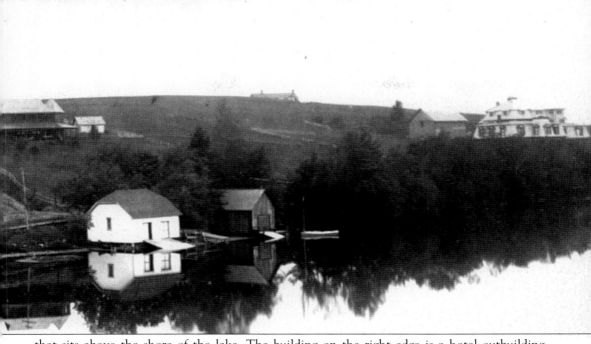

that sits above the shore of the lake. The building on the right edge is a hotel outbuilding belonging to the Lake Placid House. (Photographer C.M. Wood.)

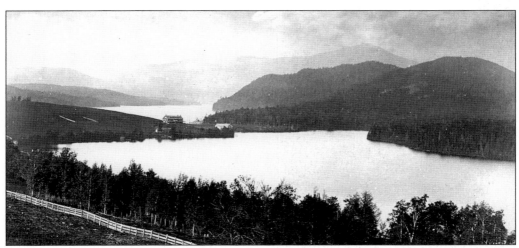

This *c.* 1880 photograph is attributed to preeminent Adirondack photographer Seneca Ray Stoddard. The photograph caption reads, "Lake Placid House, from Grand View House." Martin Brewster's Lake Placid House was erected in 1871 and was Lake Placid's first real hotel.

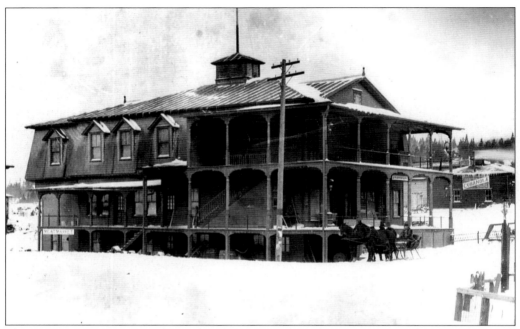

The Newman Opera House, located at the corner of South Main Street and Averyville Road, was built in 1895. It later became the hardware store of G.G. White. The porches were eventually removed, and it became known as Casey's Old Town Pub. The building still houses a pub and restaurant today. (Courtesy Mary MacKenzie.)

Today, it is hard to imagine a large expanse of lawn on the west side of Main Street in the village. The Palace Theatre is on the left in this c. 1935 photograph. It took many years of slow growth to fully develop Main Street as it is today. ($5.00 Photo Company, Canton, New York.)

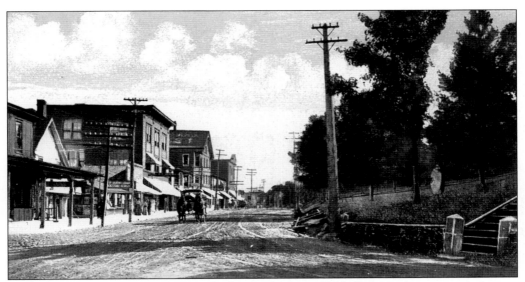

This postcard shows the northern end of Main Street *c.* 1900. Saranac Avenue starts just on the right by the stone wall. Most of the buildings on the left side were destroyed in the great fire of 1919. (Valentine & Sons, New York, New York.)

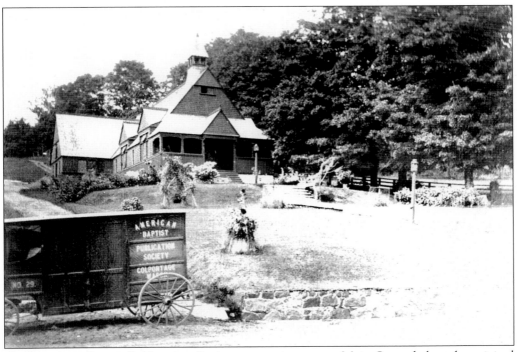

An American Baptist Publication Society wagon is seen on Main Street below the original Lake Placid Baptist church *c.* 1905. Members of the society traveled the Adirondacks and other areas of the country distributing Baptist literature. They sometimes published photo postcards of the churches and towns they visited. (American Baptist Publication Society.)

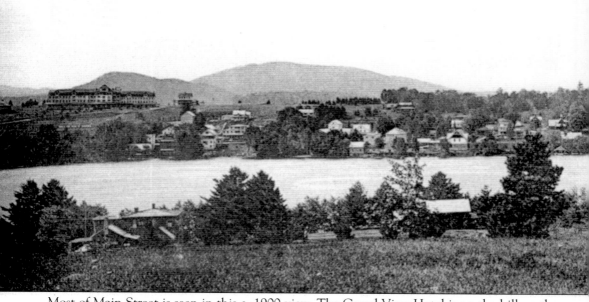

Most of Main Street is seen in this *c.* 1900 view. The Grand View Hotel is on the hill on the

This boardinghouse, *c.* 1905, was called the Adirondack and was located on Main Street across from the Bank of Lake Placid. The old Baptist church is shown next to the house. Both buildings have since been razed and replaced by a village parking lot.

14

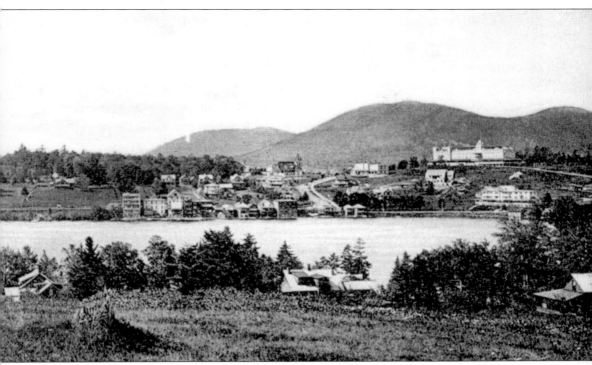

left side. The Stevens House is on the right atop Signal Hill. (H.D. Tucker, Lake Placid.)

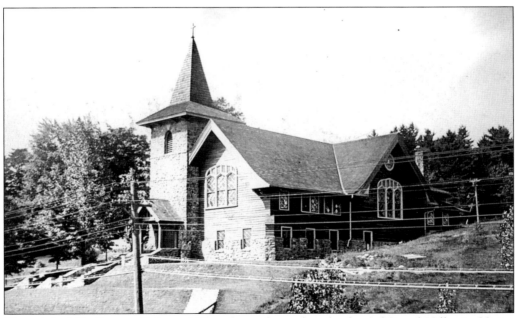

The original St. Eustace Episcopal Church was located at the foot of Signal Hill near Victor Herbert Drive. That church was dismantled and rebuilt on Main Street in 1927, as shown here c. 1930. The reconstructed church is still in use today.

The old Methodist church, built in 1888, was located on Main Street. In 1923, it was moved to a new location on School Street near Main Street. It was then enlarged and converted to a restaurant called the Ideal, run by the Wayte family. The present Adirondack Community Church was constructed near the Methodist church's old location in 1925. (Eastern Illustrating Company, Belfast, Maine.)

A group of people is seen in front of the Methodist church c. 1920. At this time, the church was used by the local Jewish congregation and by the Methodists. The Jewish congregation did not have its own place of worship. Rabbi Wise is in the center of the group. (Courtesy Mary MacKenzie.)

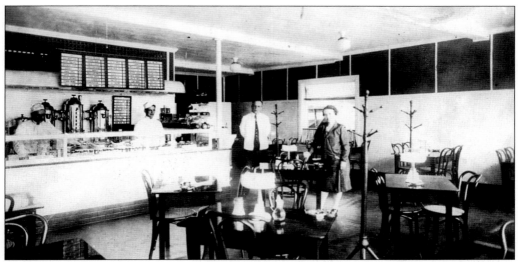

The Ideal, a restaurant located near Main Street on School Street, was owned by the Wayte family. The food was served cafeteria style, as shown in this c. 1930 photograph. The establishment was later known as the Olympic Restaurant, and today it is a nightclub called Mud Puddles.

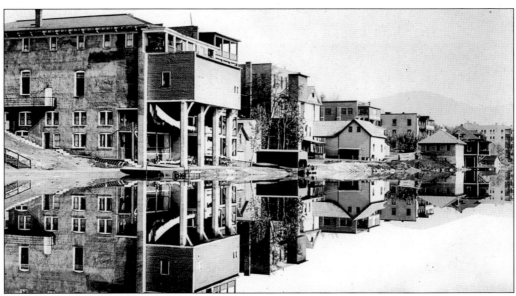

Main Street buildings are reflected in a placid Mirror Lake c. 1930. The closest building, with the second-story rear addition, was the Happy Hour Theatre. Also known as the Wanda Building, it was built in 1912 and is still located across the street from the Hotel Marcy, now called the Northwoods Inn. (Photographer Grover Cleveland.)

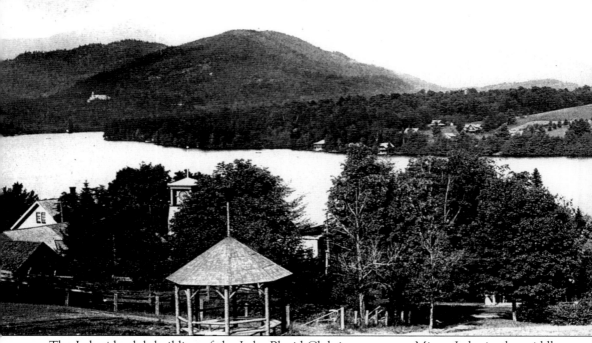

The Lakeside club building of the Lake Placid Club is seen across Mirror Lake in the middle of this c. 1905 panoramic view. The photograph was taken from the hill below the Grand

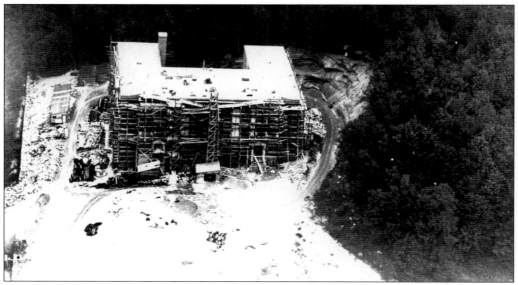

This 1922 aerial view shows the high school being built. Much of the hill to the right and behind the building had to be removed to facilitate construction.

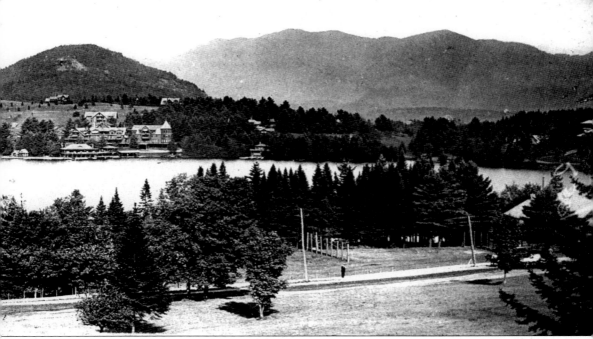

View Hotel. Main Street is seen toward the bottom of the hill. (Rotograph Company, New York City.)

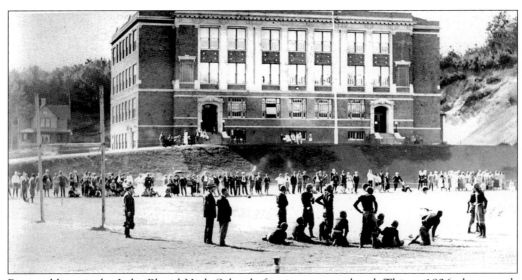

Pictured here is the Lake Placid High School after it was completed. This c. 1926 photograph shows students playing football before the building was considerably enlarged in 1936. This athletic field later became the oval speed skating rink for the 1932 Winter Olympic Games.

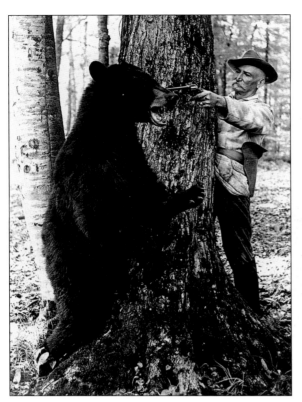

Sanford P. "Speen" McKenzie pretends to shoot a bear for the camera; this and other photographs were used to promote his business. McKenzie fought in the Civil War and was a local hunter, guide, jeweler, watchmaker, and engraver. McKenzie killed this bear on June 13, 1905, and had it stuffed. (Courtesy Mary MacKenzie.)

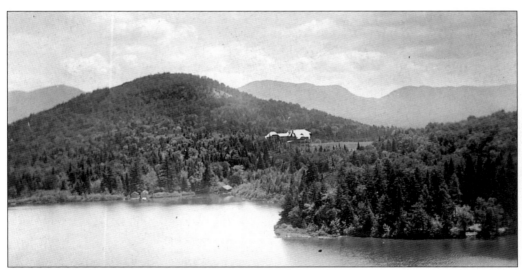

The original Hopkins School was constructed near the northeast corner of Mirror Lake c. 1912. In 1921, the school changed hands and the name was changed to the Montemare School. In 1927, it became known as the Northwood School, and it is still in existence today. (Photographer G.T. Rabineau.)

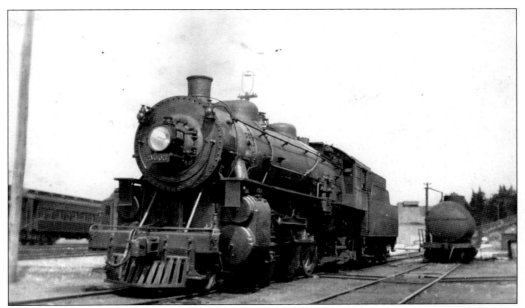

A New York Central Railroad "1911 Schenectady" locomotive is seen near the Lake Placid railroad station in 1919. This line runs from Lake Clear Junction to Saranac Lake and on to Lake Placid. At the junction, the line runs to Utica, New York.

The northern end of Mirror Lake is seen in this c. 1935 photograph taken near the start of Saranac Avenue. Mounts Whitney and Whiteface are seen in the distance. (Photographer Grover Cleveland.)

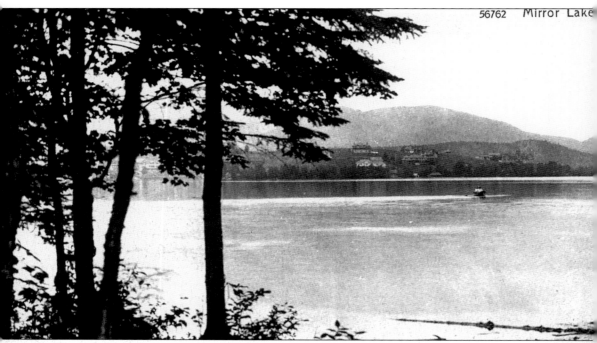

The majestic views around Mirror Lake made a great subject for panoramic photographs. The view is toward the north, from the outlet of the lake *c.* 1905. The Lake Placid Club Lakeside

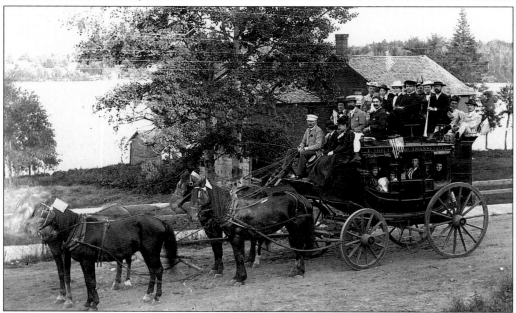

A stagecoach owned by the Lake Placid Transfer Company transports a load of passengers to their destination *c.* 1895. C.H. Green was the driver. One of the early stage lines was started by the Stevens brothers to transport people to Lake Placid from the Westport train station. The photograph was by taken by early Lake Placid photographers Brownell and Fry. (Courtesy Mary MacKenzie.)

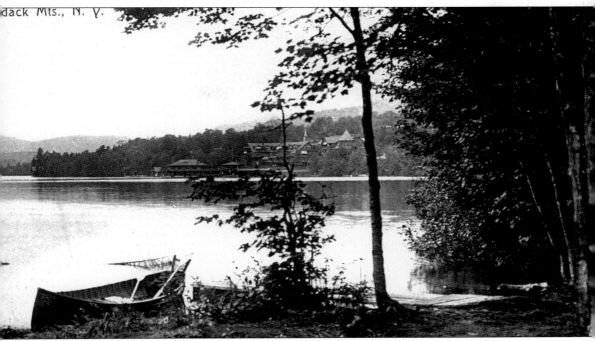

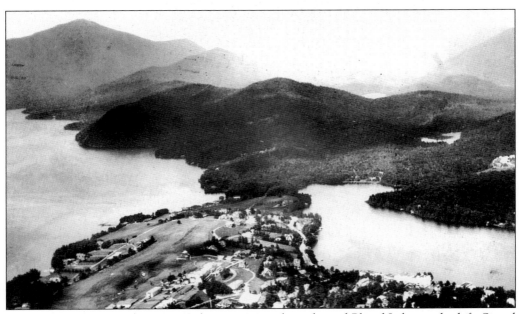

building is on the right. (Rotograph Company, New York City.)

In this aerial photograph, Mirror Lake appears on the right and Placid Lake on the left. Signal Hill is in the middle. (Photographer Grover Cleveland.)

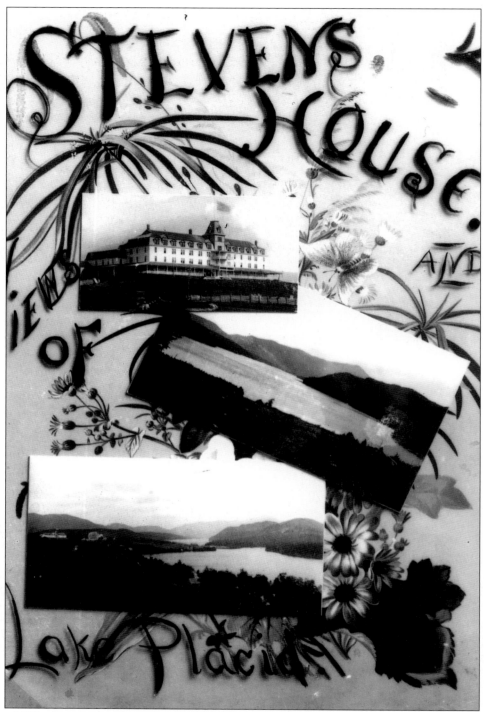

A c. 1888 advertising collage shows the Stevens House, the largest hotel in Lake Placid. The hotel was built in 1886 by John and George Stevens, two brothers from Plattsburgh. Later, the hotel could accommodate 400 guests after a large addition was added and an annex was built.

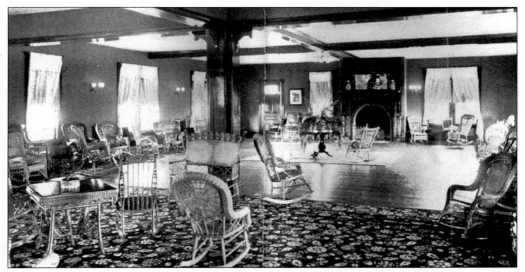

A parlor at the Stevens House is shown in this *c.* 1905 photograph from a promotional brochure. The hotel was four stories high, 40 feet wide, and 242 feet long. Its dining room was 126 by 40 feet. Sixty of its rooms had private baths. The hotel had steam heat and hot water in every room.

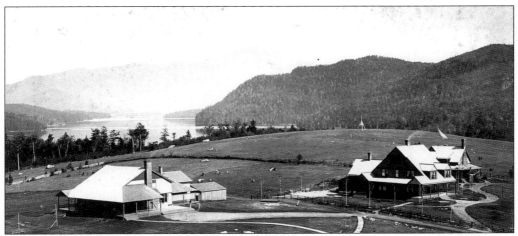

This photograph was taken from the Stevens House hotel *c.* 1890, looking toward the West Lake. The building on the left became the hotel golf house in 1900. The lawns on the hill were originally farm fields. You can see a wooden tower erected at the top of the hill. Verplanck Colvin may have built this signal tower while surveying Whiteface Mountain and Placid Lake for New York State. The area is still called Signal Hill. (Photographer Baldwin, Plattsburgh, New York.)

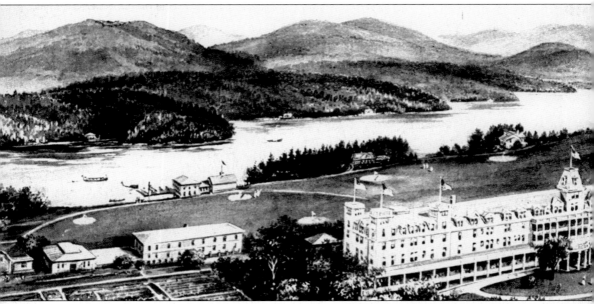

The Stevens House hotel is seen in its location at the top of Signal Hill. The panoramic postcard view was made from a painting *c.* 1903. Lake Placid is on the left and Mirror Lake is

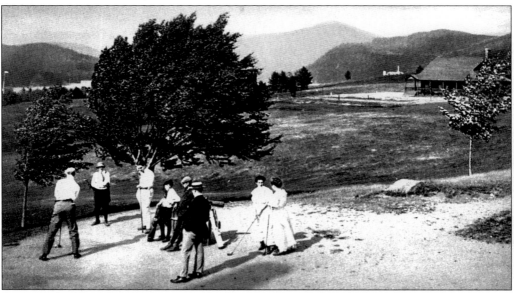

A party of golfers plays the game on the Stevens House links *c.* 1905. The course was located on Signal Hill near the hotel. John Duncan Dunn was the course professional for many years. He was the older brother of Seymour Dunn, Lake Placid Club golf professional. (Detroit Publishing Company, Detroit, Michigan.)

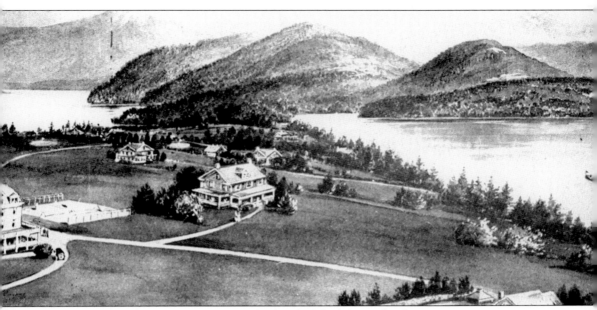

on the right. Whiteface Mountain sits at the head of the lake in the distance.

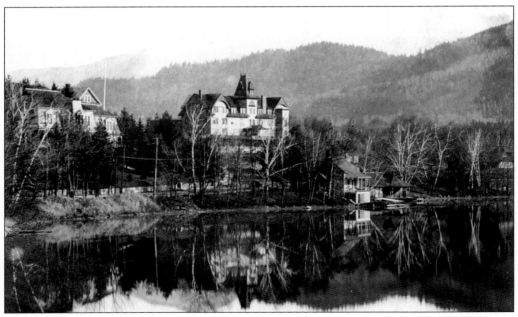

The first actual hotel constructed in Lake Placid village was the Lake Placid House, or Brewster's, as it was known. It was built between Mirror and Placid Lakes in 1871 by Benjamin Brewster, a local farmer. The hotel was later remodeled and enlarged, and the name was changed to Lake Placid Inn. The inn burned in 1920 and was not rebuilt. This photograph was taken c. 1915. (Lockwood Shop.)

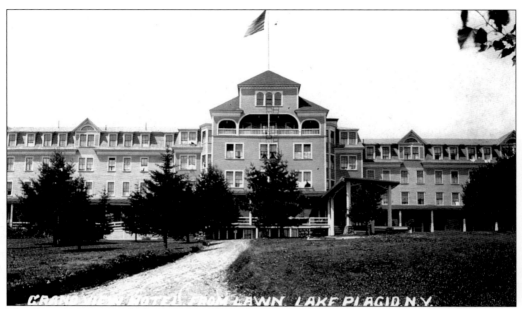

The Grand View Hotel, shown *c.* 1910, was built by Moses Ferguson in 1878. Ferguson erected the building on a hill with a spectacular view of Mirror Lake. In 1881, he sold the hotel to Henry Allen, who expanded his property holdings and the hotel itself until it became the second largest in the village. (Photographer Henry Beach, Remsen, New York.)

The Grand View Hotel appears to be in good condition in this *c.* 1950 photograph. The elegant porte-cochere gave arriving or departing guests protection from inclement weather. The hotel was razed in 1961, and the present Holiday Inn was soon constructed. ($5.00 Photo Company, Canton, New York.)

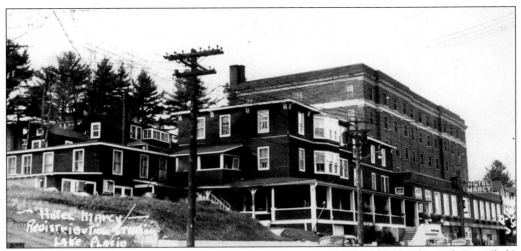

The Hotel Marcy was constructed in 1927 on Main Street. The old Northwoods Inn (left) became an annex of the new hotel at that time. A few years ago, the Marcy changed its name to the Northwoods Inn. This photograph was taken c. 1945. (Photographer J. Fisher.)

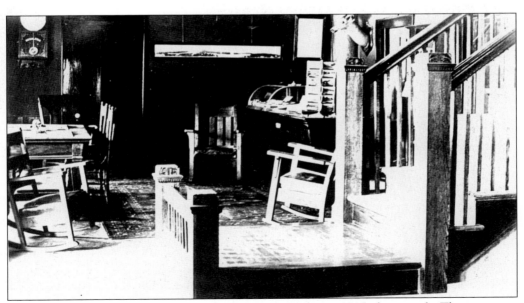

The front desk area of the Northwoods Inn is seen in this c. 1915 photograph. The inn was a small hotel located on the south end of Main Street. Simple furnishings decorate the room. (Photographer Irving L. Stedman.)

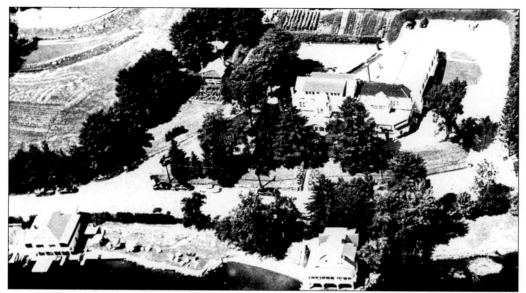

The Mirror Lake Inn is seen in an aerial view c. 1945. The inn burned in 1988 and was replaced by a larger Mirror Lake Inn. The inn still owns cottages on the west shore of Mirror Lake. (Portland Lithograph, Portland, Maine.)

The Mirror Lake Inn, as seen c. 1945, has been one of the most popular hotels in the village for many years. Its beach was located 200 feet from the hotel on Mirror Lake. For many years, the hotel grew its own produce to ensure freshness at its gourmet restaurant.

The residence of Albert Billings was located on the north end of Main Street. Billings was a guide boat builder, and his workshop on Placid Lake later became the George & Bliss boat garage. This building at the edge of Mirror Lake, shown *c.* 1900, was later bought by the Mirror Lake Inn and is now known as the Colonial House.

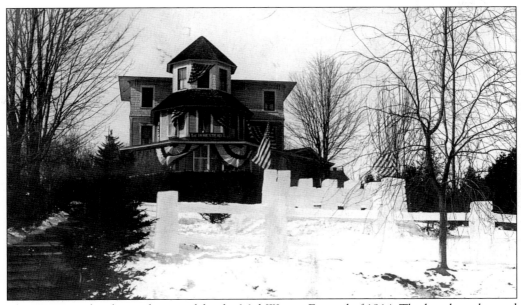

The Homestead is shown decorated for the Mid-Winter Festival of 1914. The hotel was located on the north end of Main Street and was demolished in 1978 to build the present Hilton Hotel. (Photographer Irving L. Stedman.)

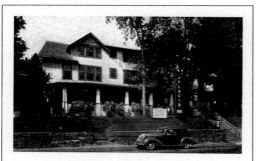

This *c.* 1935 advertising card for the Lake Placid Inn shows the Main Street property before the lawn was removed and the basement opened to the street. The establishment was later known as the Alford Inn. Today, it houses a large rustic furnishings store. It is the oldest building extant on Main Street. (Santway Photo-Craft Company, Watertown, New York.)

Let us Help to Make Your Visit
to
*Lake Placid*
an Enjoyable One

*Stop at the*
## LAKE PLACID INN
A   REAL   ADIRONDACK   INN

Comfortable  Beds          Excellent  Food
Cozy          Homelike          Friendly
Reasonable  Rates

American and European Plans          Free Parking
Conveniently  Located  in  the  heart  of  the  town .

FRANK W. and HELENE T. SWIFT
Telephone 210

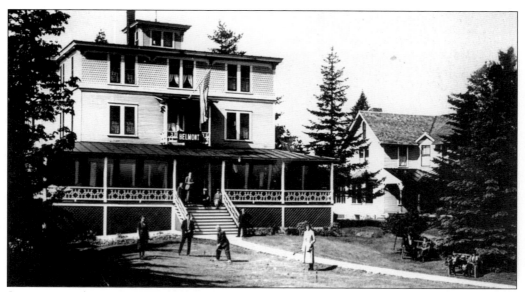

Some guests play croquet on the lawn of the Hotel Belmont *c.* 1935. The Belmont was located on Saranac Avenue just west of the St. Moritz Hotel.

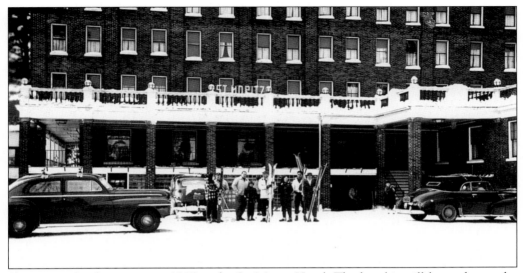

Skiers pose for the camera c. 1945 at the St. Moritz Hotel. The hotel is still located near the top of the hill on Saranac Avenue. In 1943, it was bought by Goodman Kelleher and renovated. ($5.00 Photo Company, Canton, New York.)

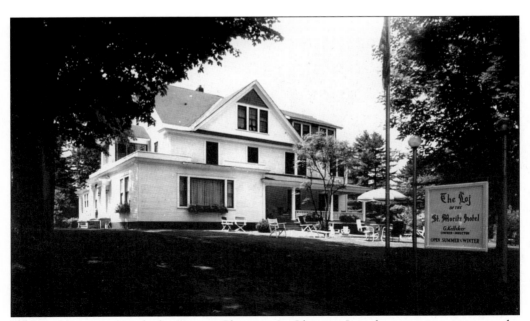

This building, previously known as Cheesman's Olympic Inn, became an annex to the St. Moritz Hotel in the 1950s and was called the Loj. The 39 Saranac Avenue building is still in use today.

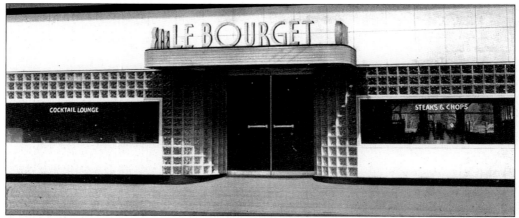

The Le Bourget restaurant was located on Main Street opposite the Palace Theatre. James Hadjis owned the popular restaurant shown in this *c.* 1950 postcard. (Barton Press Inc.)

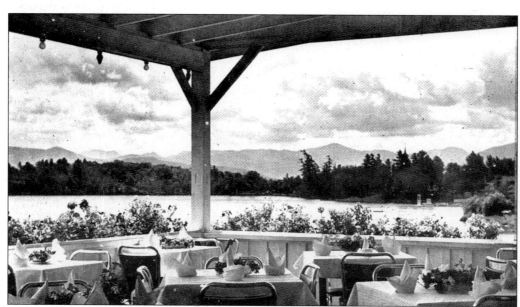

In nice weather, patrons of Le Bourget had an exquisite view from the outdoor dining porch overlooking beautiful Mirror Lake. (Adler Advertising, Binghamton, New York.)

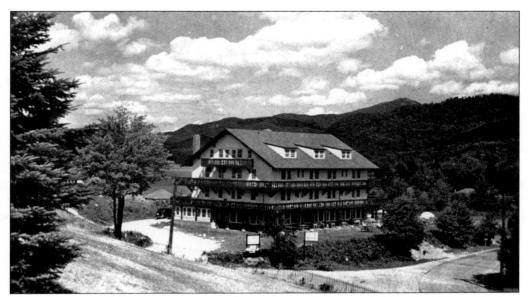

The Chalet, a small hotel, was constructed near the site of Brewster's Lake Placid Inn. The inn, which burned in 1920, had been the village's oldest hotel. This site was between Mirror and Placid Lakes, near the Carry. Later, the Chalet was torn down and a condominium complex was built. (Eagle Post Card View Company, New York City.)

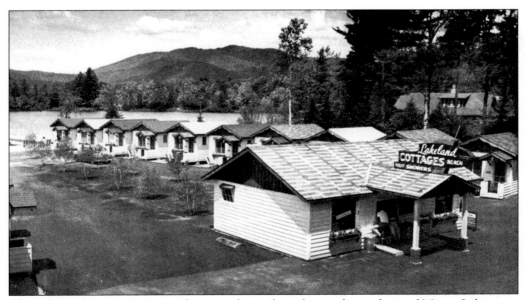

The Lakeland Beach Cottage colony was located on the northeast shore of Mirror Lake, near Northwood Road. This postcards caption reads, "Lake Placid's Newest & Largest Cabin Colony. Twenty Modern Cottages on Beautiful Mirror Lake." These cabins would not fit in with the present private homes lining Mirror Lake Drive.

# Breakfast

Saturday, September 8th, 1894.

Baked Apples,        Oranges,        Stewed Prunes.

Cracked Wheat,        Hominy,        Oat Meal.

Broiled Bluefish,        Broiled Salt Mackerel.

Sirloin Steak,
Lamb Chops,   Breakfast Bacon,        Broiled Ham.

Fried Indian Pudding,        Codfish Balls.
Corned Beef Hash.

Eggs, Boiled, Fried, Scrambled & Poached.
Omelet, Plain, with Ham, Parsley & Jelly.

Potatoes:
Baked,        Lyonnaise,        Stewed.
French Fried.

French Rolls,     Corn Muffins,    Coffee Rings.
Griddle Cakes, Popovers, Graham Gems.

Tea,     Coffee,     Milk,     Cocoa,  Chocolate.

The Mirror Lake House breakfast menu for September 8, 1894, offered extensive choices to hotel guests. The hotel burned to the ground a few weeks later and was not rebuilt. This hotel was located on the hill between the 1932 Olympic Arena and the Holiday Inn. In 1894, the hotel was owned by Paul Smith and partners.

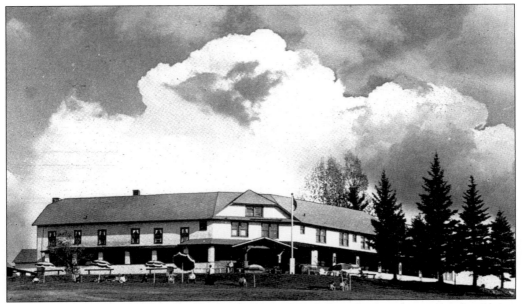

The Fawn Club lodge and golf course was built in 1921. It later became known as the Alpine Lodge and Motel, as seen in this *c.* 1950 postcard. The complex was razed in the 1960s, and the Alton Jones Cell Science Center was built.

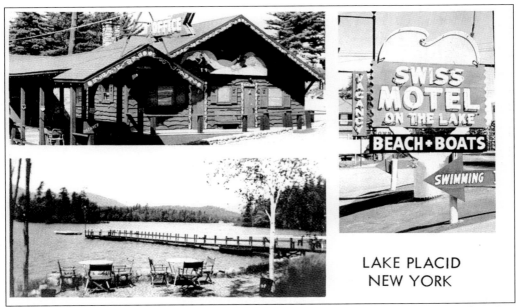

The Swiss Motel was located at the corner of Saranac Avenue and Victor Herbert Road. Today, Paradox Landing and the Baptist church occupy the property on Paradox Bay of Placid Lake.

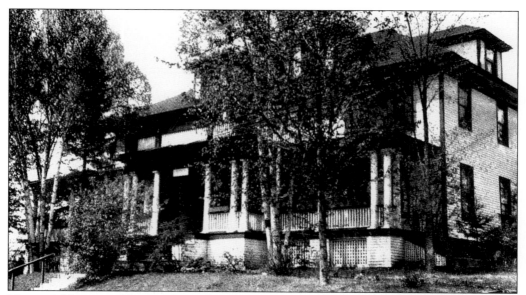

Newton's Homewood Inn was located at 15 Interlaken Avenue on Signal Hill. The small hotel is now called the Interlaken Inn and has an intimate, upscale restaurant. (Albertype Company, Brooklyn, New York.)

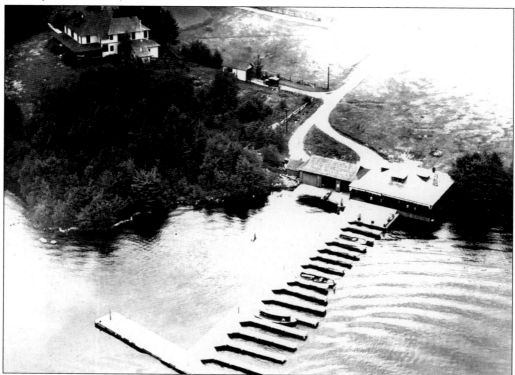

The private Lake Placid Yacht Club is shown in this *c.* 1925 aerial photograph. The club buildings were built in 1907 on the East Lake near the George & Bliss boat garage. (Hamilton Maxwell, New York City.)

# *Two*
# PLACID LAKE

To differentiate Lake Placid village from the lake by the same name, "Placid Lake" will be used when referring to the lake. The east half of Placid Lake, called the East Lake, is seen in this *c.* 1885 photograph taken from Brewster's Lake Placid House. The hotel was located near the carry between Mirror and Placid Lakes. (Photographer Seneca Ray Stoddard, Glens Falls, New York.)

1923. Lake Placid from Lake Placid House.

A cove on the east shore of the East Lake is shown in a Chester D. Moses photograph *c.* 1897. The Placid Lake shore looks much different today due to changes in lake depth and camp and

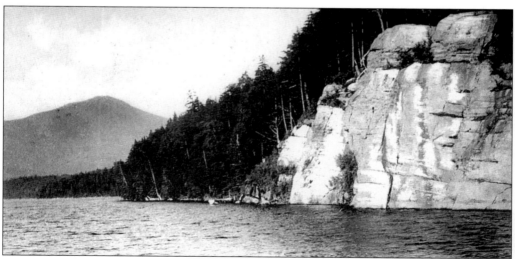

Pulpit Rock is a popular attraction for boaters on the East Lake. Daring young people have been high diving from the cliff for many years. The lake is over 100 feet deep straight down from the vertical rock wall. Whiteface Mountain is seen in the distance in this *c.* 1900 postcard. (Rotograph Company, New York City.)

commercial construction. It took many years to remove the hundreds of dead trees, stumps, and rocks to make boat navigation safer. (Courtesy Mary MacKenzie.)

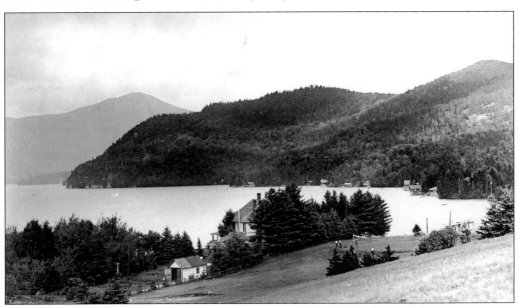

Most of the southern end of the West Lake is shown in this *c.* 1930 photograph. As camps were built, the look of the shoreline changed drastically. It is still changing today as new camps are built and existing ones are remodeled. Thankfully, condominium projects have been held to a minimum.

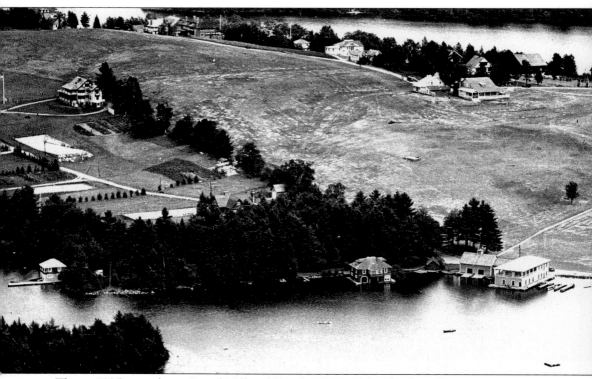

This c. 1925 view shows Signal Hill and Paradox Bay on Placid Lake. The Stevens House hotel sits at the top of the hill. The Stevens House white boathouse sits to the right of the trees on

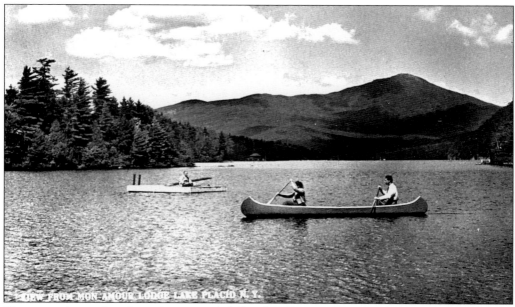

VIEW FROM MON AMOUR LODGE LAKE PLACID N. Y.

Two canoeists enjoy the calm waters of Paradox Bay on Placid Lake c. 1945. Whiteface Mountain sits at the far end of the lake. (Photographer Jungmann, New York City.)

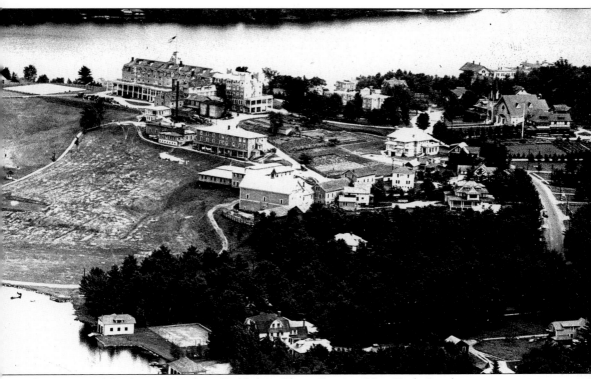

the upper middle shore of the bay. (Publishers Photo Service, New York City.)

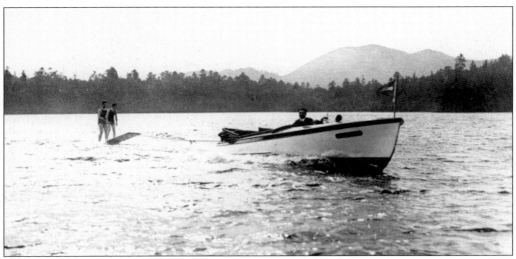

Two adventurous people are seen aquaplaning behind an early motorboat on Placid Lake c. 1925. The aquaplane was just a board pulled by the boat. Water skis were a later invention. (Photographer G.T. Rabineau.)

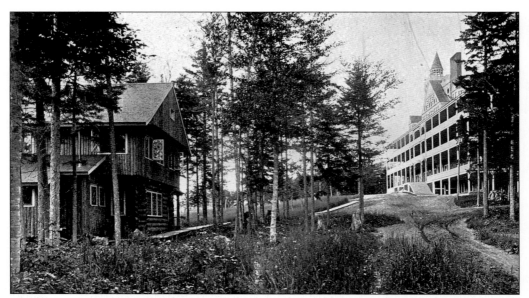

The Ruisseaumont Hotel was erected on the east shore of the East Lake in 1892. The large hotel had a number of rustic cottage outbuildings, one of which can be seen to the left of the hotel. The hotel burned to the ground on July 2, 1909, and was not rebuilt.

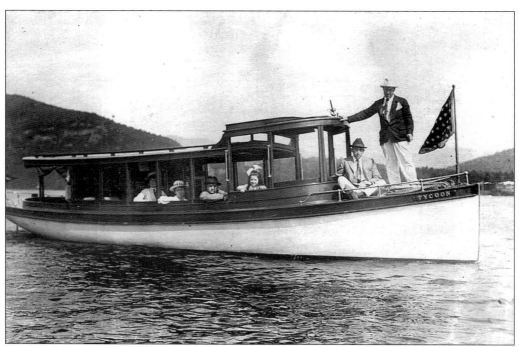

The Ruisseaumont motor launch *Tycoon* is seen on Placid Lake *c.* 1915. This gasoline-powered craft had pleasing lines. (Courtesy Mary MacKenzie.)

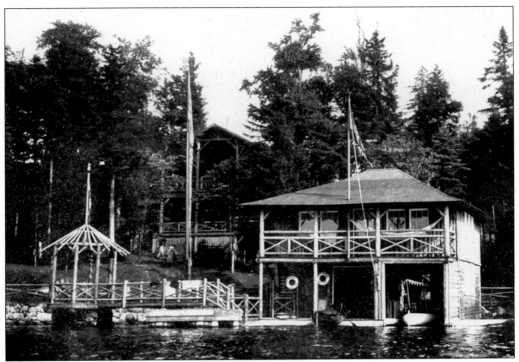

Camp Irondequoit was built on the east shore of Placid Lake *c.* 1900. Irondequoit means "where the waves breathe and die." The camp was built for Rev. William Moir and was used to provide spiritual and physical recreation for boys. Moir was instrumental in the construction of the first St. Eustace Episcopal Church and in the organization of a Lake Placid youth hockey team in the 1890s.

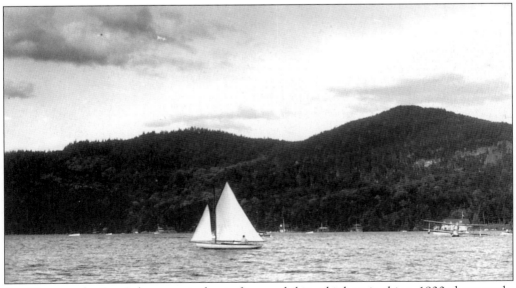

A sailboat on the East Lake passes in front of an amphibious biplane in this *c.* 1930 photograph. Mount Whitney is seen in the distance. Sailing is still a pastime for people on the lake today.

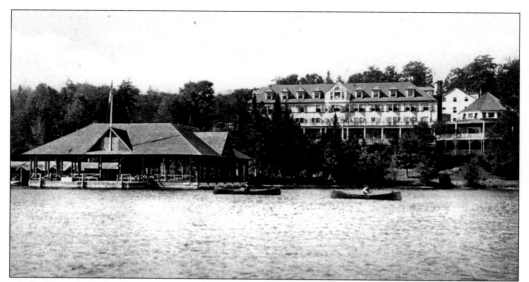

This is the Whiteface Inn, built in 1901. The hotel burned on May 20, 1909, but was rebuilt in 1915. The inn had a magnificent view of the West Lake and Whiteface Mountain. (Detroit Publishing Company, Detroit, Michigan.)

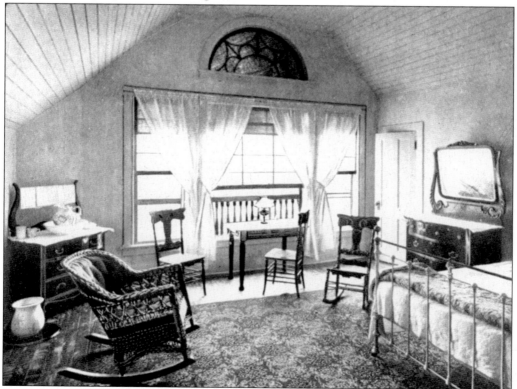

Guest bedrooms at the Whiteface Inn appear to be very comfortable for their day, as shown in this c. 1905 photograph from a hotel brochure. The hotel remained open until the early 1980s under various owners and management.

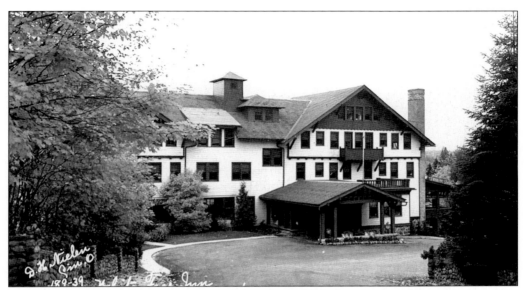

The porte-cochere and main entrance of the rebuilt Whiteface Inn are shown *c.* 1939. This entrance did not have a particularly good scenic view, but the lake view on the other side made up for it. The spectacular Whiteface Mountain and West Lake views were a large hotel attraction. (D.H. Neilen, Cincinnati, Ohio.)

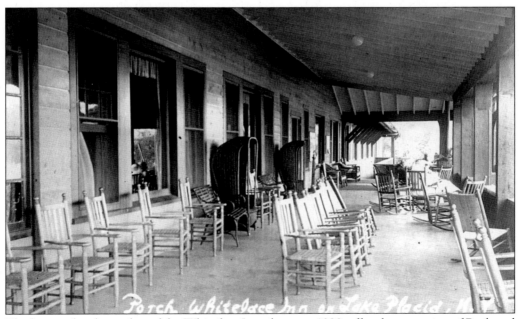

The long and wide porches of the Whiteface Inn, shown *c.* 1920, offered a great view of Buck and Moose Islands, the West Lake, and Whiteface Mountain. (Photographer Irving L. Stedman.)

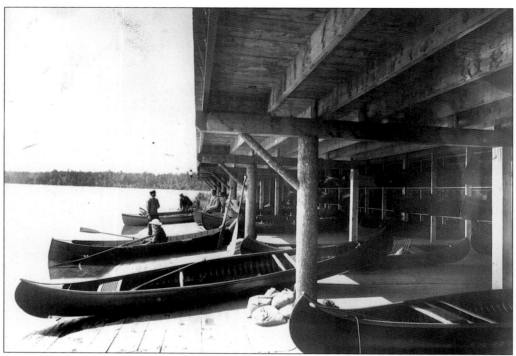

The Whiteface Inn offered numerous guide boats and canoes for guests to use. This c. 1890 photograph shows inn boatmen ready to help guests with the boats. Many small boat regattas were held there throughout the years.

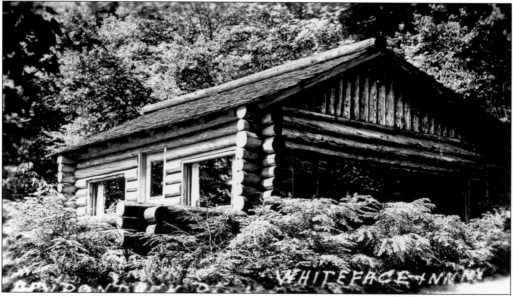

Many small log cottages were constructed on the lawn of the Whiteface Inn, near the shore of Placid Lake. Many have a grand view of the West Lake and Whiteface Mountain in the distance. Today, most remain and are used as guest accommodations for neighboring Lake Placid Lodge.

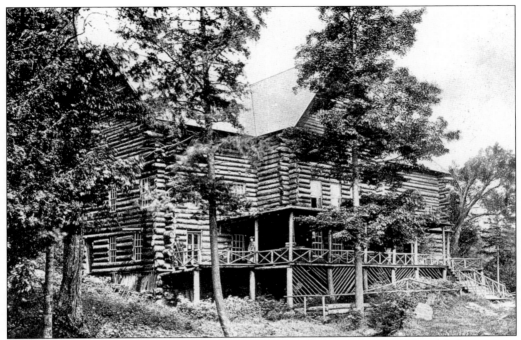

Castle Rustico was built by William Fox Leggett on the west shore of Placid Lake next to Minnow Brook in 1879. The massive structure, seen *c.* 1890, was one of the largest all-log buildings ever constructed in the Adirondacks. Leggett used it as a resort for his artistic friends. He died in 1910, and the castle was then run as a guesthouse until the late 1920s. It was razed in the 1950s after sitting abandoned and rotting for more than 20 years.

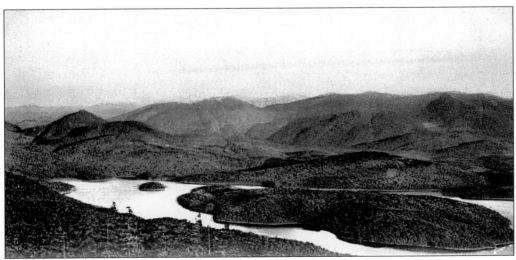

Moose Island, as seen from Mount McKenzie, shows the north end of Placid Lake. The Sentinel Mountain Range is seen in the distance. (Rotograph Company, New York City.)

This *c.* 1905 panoramic view shows the West Lake from the Whiteface Inn shore. The Lake Placid Club boat *Morningside* is seen just offshore. Whiteface Mountain overlooks the lake at

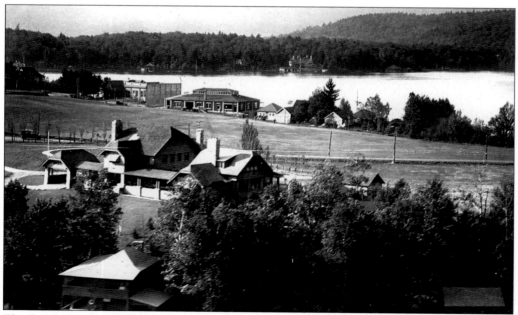

The house in the foreground of this *c.* 1925 photograph was known as Interlaken and was owned by the Maxwell family. The house is still privately owned. The rebuilt George & Bliss boat garage is in the background; the previous one burned in the spectacular lakefront fire of February 1919. (Publishers Photo Service, New York City.)

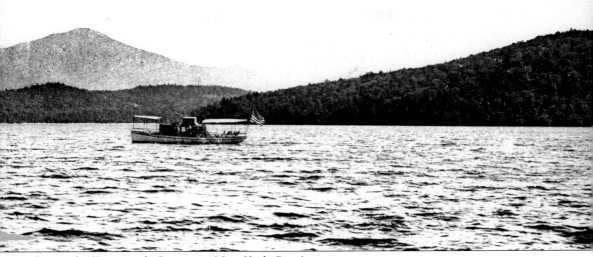

the north. (Rotograph Company, New York City.)

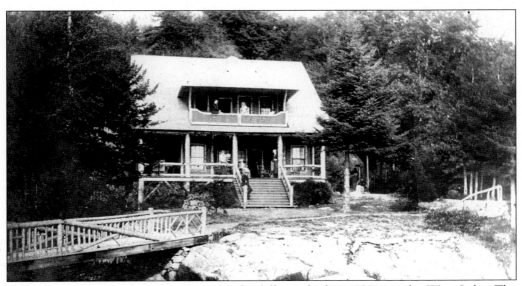

Skanadario, the main house at Camp Undercliff, was built in 1901 on the West Lake. The Native American meaning for Skanadario is "home by the beautiful lake." Skanadario still has a glorious view of Whiteface Mountain, located just to the north. This photo postcard was postmarked at the Undercliff Post Office on August 15, 1909.

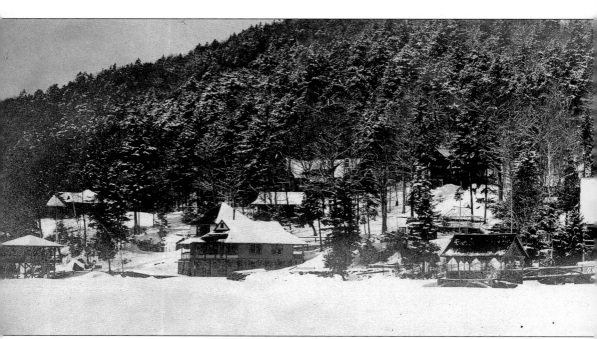

The many buildings of Camp Undercliff are shown in midwinter *c.* 1910. The first buildings at the camp were built by Charles Alton in the early 1880s. The camp was enlarged and opened to

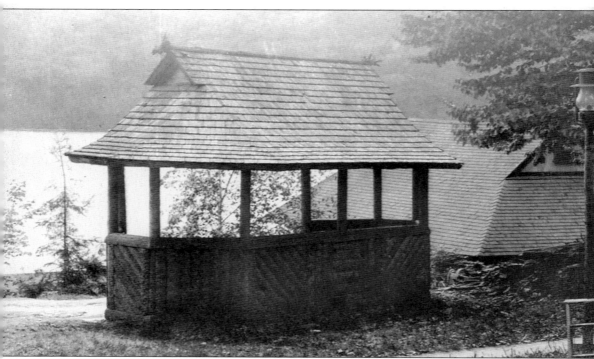

A gazebo is shown behind the casino at Camp Undercliff *c.* 1900. The camp was then owned by Dr. Charles and Marguerite Alton and was run as a small resort hotel. They closed Undercliff

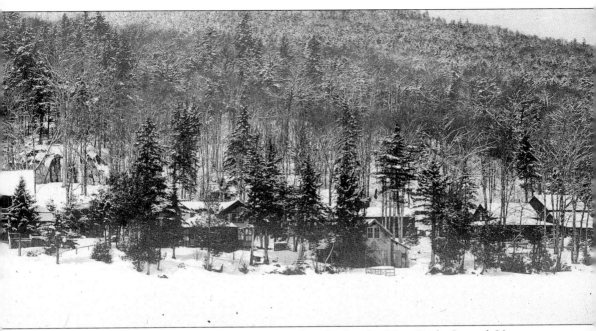

paying guests in 1889. In 1924, the camp was bought by the New York Central Veterans Association, to be used as a seasonal resort by members. (Photographer William Cheesman.)

in 1912, and the property was put up for sale. (Courtesy Mary MacKenzie.)

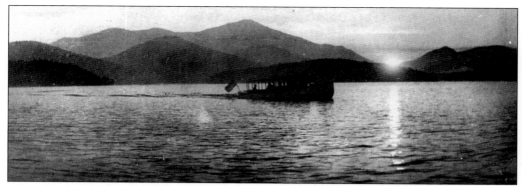

The sun rises through Sunrise Notch at five in the morning near Camp Undercliff c. 1910. Whiteface Mountain is to the left of the notch.

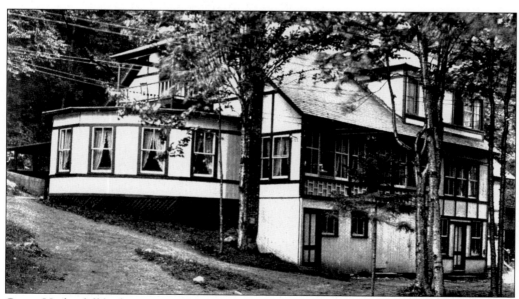

Camp Undercliff had many small buildings for guest and employee housing, recreation, and other uses. The camp was a rustic retreat for retired New York Central Railroad employees when this postcard was mailed on August 4, 1929.

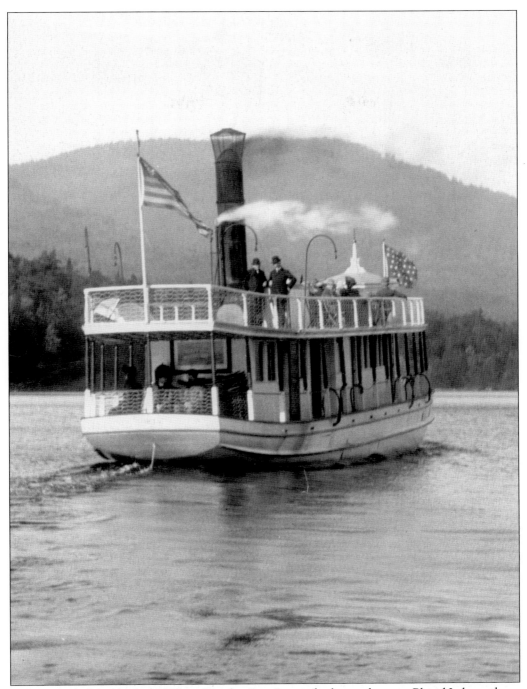

The *Doris* was launched in 1898 on Paradox Bay. It was the largest boat on Placid Lake and was used to carry passengers and mail to and from the many camps and hotels on the lake until 1950. This *c.* 1905 photograph shows the boat with its steam engine smokestack still in use. A more modern gasoline engine was installed *c.* 1910, and the black stack was removed.

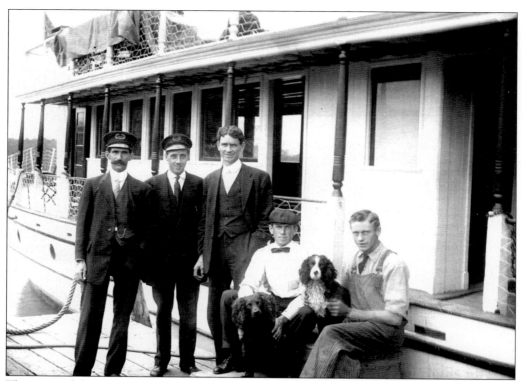

The crew of the *Doris* is shown *c.* 1912. Arthur C. Stevens was captain of the first *Doris* for approximately 50 years and of the *Doris II* for 10. The boat made three trips per day around the lake for most of its 52 years. (Courtesy Mary MacKenzie.)

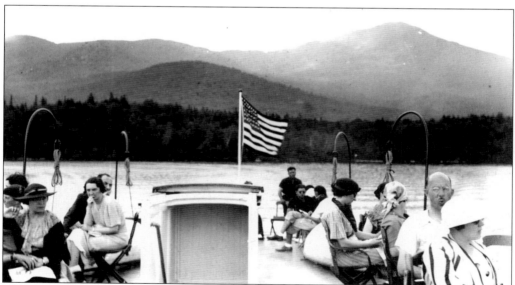

Passengers are seen on the top deck of the *Doris c.* 1935. The venerable tour boat was equipped with only two small lifeboats; you can see the davits for them just behind the passengers. When the weather was nice, this certainly was the place for a great view.

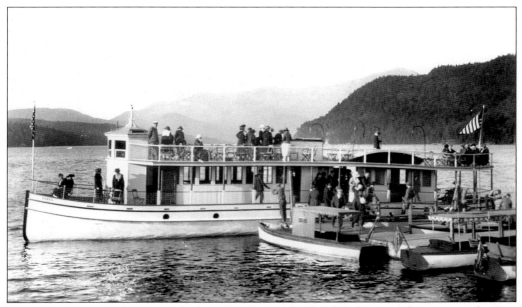

The *Doris* is seen tied up at its dock at the George & Bliss boathouse and garage on the East Lake *c.* 1925. (Photographer G.T. Rabineau.)

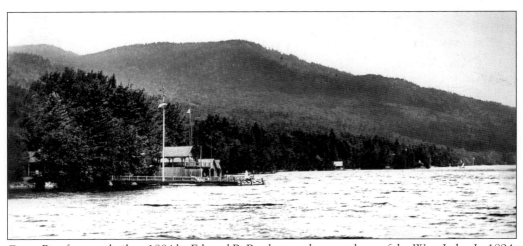

Camp Pinafore was built *c.* 1884 by Edward B. Bartlett on the west shore of the West Lake. In 1894, Bartlett sold the camp to Charles W. McCutchen, and the name was changed to Asulykit (as you like it). The camp is still owned by McCutchen's grandson. (Photographer G.T. Rabineau.)

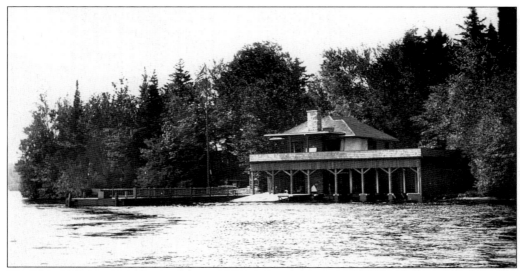

The Camp Menawa boathouse, seen *c.* 1940, no longer exists at the West Lake camp. A smaller boathouse replaced it after it burned. The camp, built in 1900, was previously known as Shawandassee. (Photographer G.T. Rabineau.)

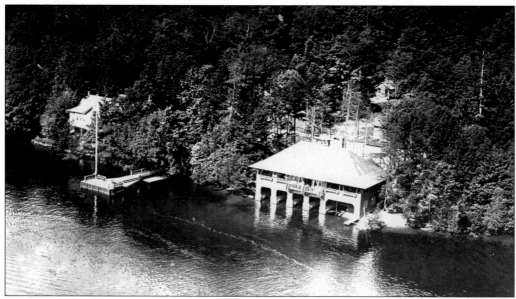

The live-in boathouse of Camp Little Brook was built in 1904 on the west shore site of a previous camp called the Beeches. There are only a few live-in boathouses left on Placid Lake today, and by law, no new ones can be built. This camp was owned by A.L.D. Warner when this *c.* 1922 aerial photograph was taken. The neighboring Camp Shawnee can barely be seen on the left. Little Brook was later owned by the Alton Jones family.

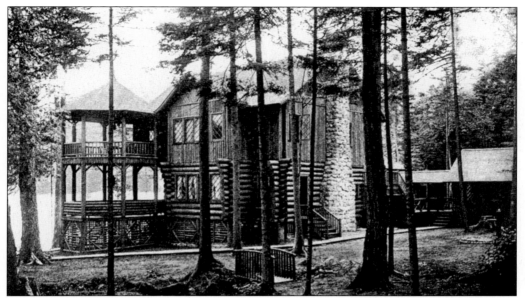

William G. Leland built Camp Idillio on the west shore of Placid Lake in 1898. The two-story attached gazebo on the left was removed some years ago. Gazebos were very popular in the late 19th century and were often called summerhouses. The camp was bought by Benjamin Ward *c.* 1900 and was renamed Beechward. In 1918, the Wards changed the name to Grenwolde.

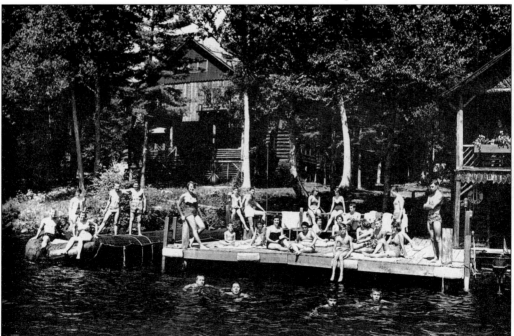

Elva and Joe Kelsall bought Grenwolde in 1953. They established a summer chamber music camp for children there and called it Camp Solitude. The camp prospered for more than 20 years and has been run as a seasonal resort by the Kelsall family since the closing of the music camp in the 1970s. This photograph was taken from a camp brochure dating from *c.* 1958.

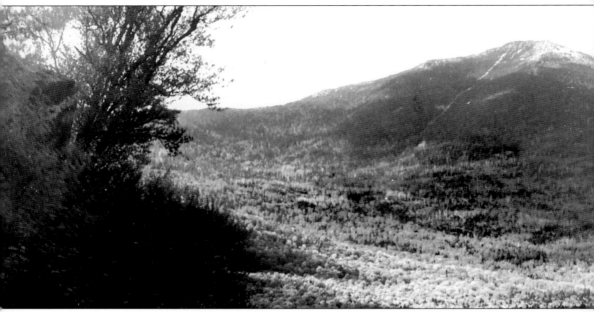

Whiteface Mountain sits majestically at the northern end of Placid Lake in this c. 1905 photograph. For more than 100 years, a dock located at Whiteface Landing has given boaters

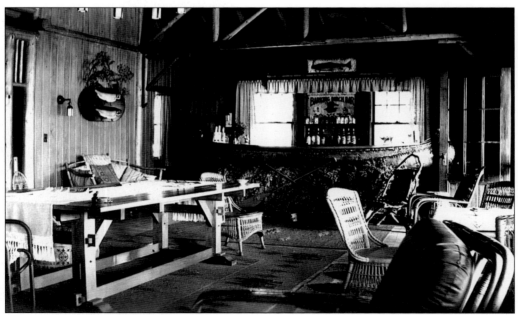

This c. 1935 photograph offers an interior view of the Henry Uihlein family's Camp Birchwood boathouse. This camp was located in Whiteface Bay at the northern end of Placid Lake. A birch-bark canoe with a plywood top served as Uihlein's rustic Barking Birch Bar. The camp was burned by the state when it became Adirondack Park property many years ago.

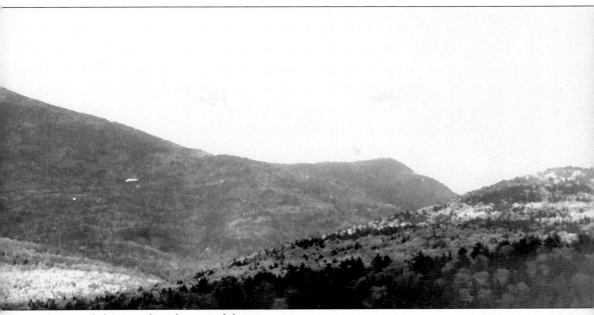

access to a hiking trail to the top of the mountain.

This small stone cottage at Camp Birchwood was located down the hill toward the lake. The cottage, pictured c. 1930, still stands and is sometimes used for illegal camping today.

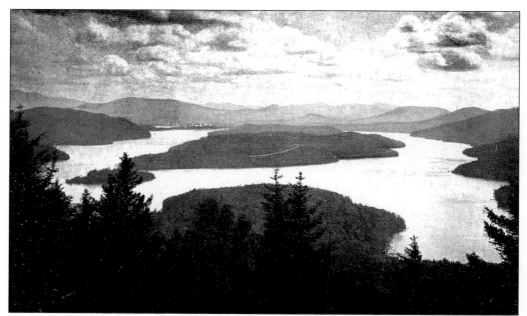

The view from Eagle's Eyrie *c.* 1895 is certainly a spectacular one. Artistically displayed by Mother Nature are Placid Lake; Hawk, Moose, and Buck Islands; and the Southern Range.

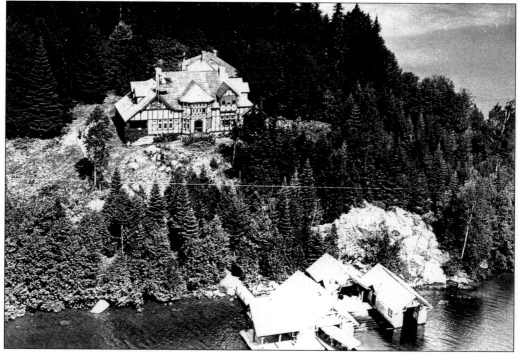

Hawk Island Camp is shown in an aerial photograph. The camp was built by Rev. Henry Potter in 1898. When this *c.* 1922 photograph was taken, the camp was owned by the P.C. Fuller family. The small island is situated at the north end of Placid Lake and is still privately owned.

Popular singer Kate Smith is shown in front of the Main House at her beloved Camp Sunshine in 1975. She broadcast her weekly radio show from her boathouse in the early 1950s. The camp is still located in Sunset Strait on Placid Lake. Smith died in 1986 and is buried in a Lake Placid cemetery.

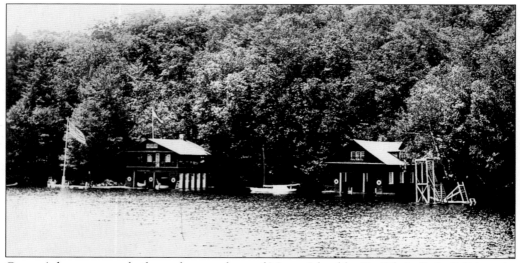

Camp Askenonta was built on the east shore of Moose Island by Dr. Edwin R.A. Seligman in 1905. Two boathouses are shown in this c. 1930 photograph. In 1949, the property was given to the Boy Scouts of America Onondoga Council. The scouts used the camp until 1962, and the property then became Adirondack Park land. (Photographer G.T. Rabineau.)

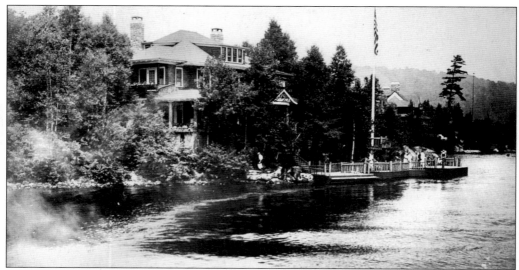

Camp Schonoe was built by Robert D. Benson on the east shore of Buck Island in 1910. The Benson family built three camps in close proximity in this area: Highwall, Schonoe and Majano. Ray Bolger was a frequent visitor to Schonoe when it was owned by Leon Leonidoff. The house no longer exists, but a boathouse was built to the left of the old house's location in 2003.

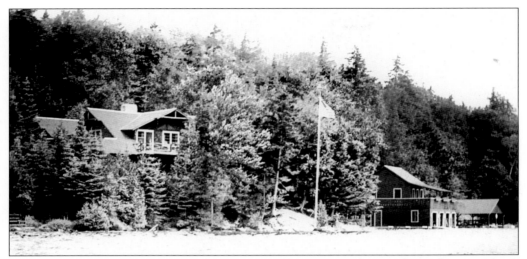

Indian Point Camp was built by Benjamin Dimmick in 1903 on the east shore of Moose Island. The main house burned in 1946 and was not rebuilt. The boathouse was then converted to a live-in residence. The camp was owned by the Rose family when this c. 1930 photograph was taken.

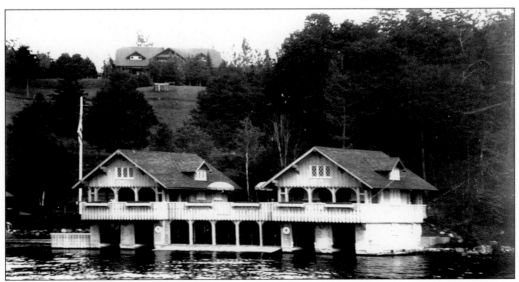

The Ruisseaumont Clubhouse is shown in this c. 1935 photograph. The boathouse was used by members of the Ruisseaumont Colony as a shared building. Moritz Rosenthal bought the camp above the boathouse c. 1913. Today, his descendants call the camp Humdinger Hill. The boathouse is now part of Camp Eagle Bear.

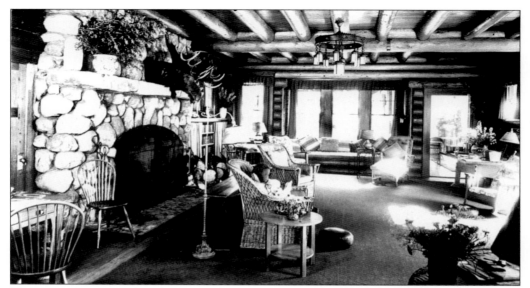

The rustic Camp Carolina living room is seen *c.* 1935. The Camp Carolina main house was used as a set for the 1990 action movie *McBain*. The camp was built on the East Lake in 1915 for Caesar Cone, a North Carolina textile manufacturer.

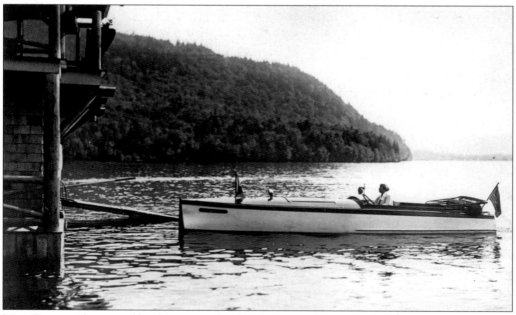

Mrs. Cone guides one of her boats into her boathouse at Camp Carolina *c.* 1930. She loved to fish and to use the boats at her camp. Pulpit Rock is at the end of the point in the distance.

# *Three*
# THE LAKE PLACID CLUB

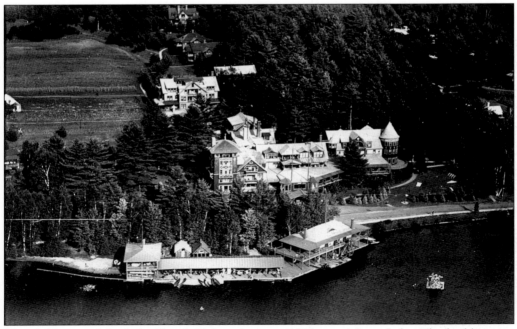

The clubhouse of the Lake Placid Club is shown *c.* 1922 near Mirror Lake. The building was demolished in 1946. The boathouse on the left is also gone, but the one on the right is now a restaurant. (Photographer Hamilton Maxwell, New York City.)

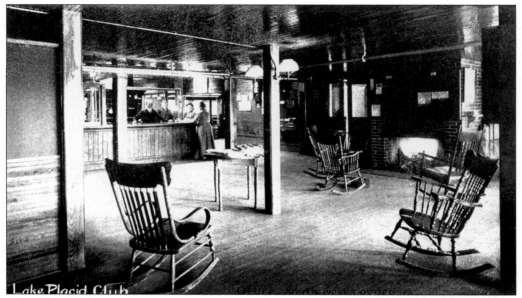

This *c.* 1900 photograph shows the office of the Lake Placid Club, located in the Lakeside building. The central office was later moved to the more modern Forest Hall. The Lakeside was razed in 1946.

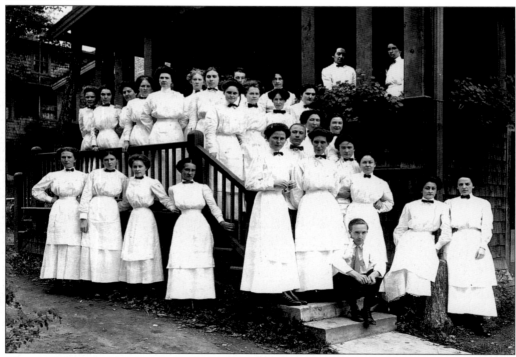

This *c.* 1900 view shows a group of Lake Placid Club employees posing in their white uniforms. Many hundreds of local residents worked at the club over the more than 85 years of its operation. During its busiest years, the club was the largest Lake Placid employer. (Courtesy Mary MacKenzie.)

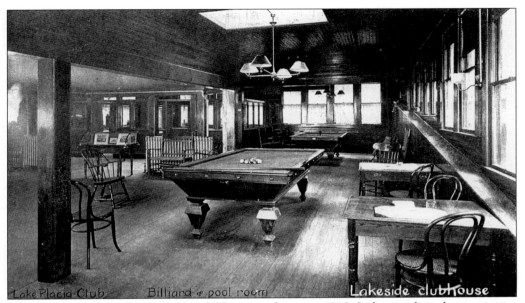

The billiard room at the Lakeside Clubhouse is shown *c.* 1910. Indoor and outdoor activities were an important part of club life. Gas lighting in the building was probably a constant worry for management and guests.

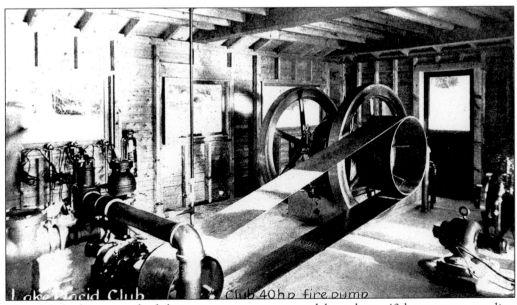

The club had its own firefighting water pump powered by a large 40-horsepower gasoline engine, as seen in this *c.* 1910 photograph. The engine could be started quickly when needed.

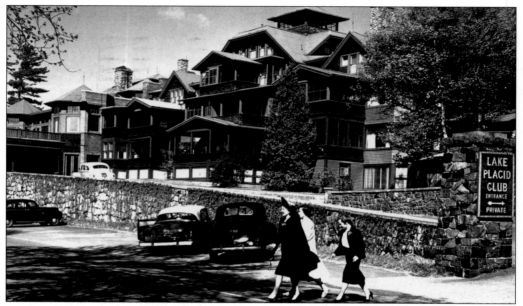

The entrance to the Lake Placid Club c. 1952 was a busy place at the private resort. Forest Hall is seen in the background. All that remains of this scene today is the stone wall and the macadam on Lake Placid Club Drive.

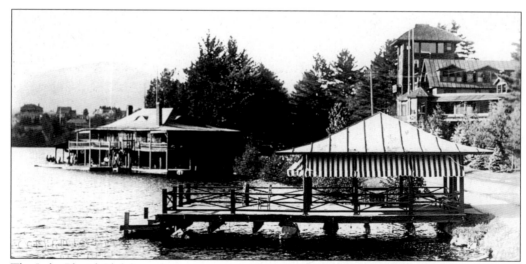

The Lake Placid Club boat dock is shown c. 1930. Boats tied up at the Mirror Lake dock to take members to the village and for tours of the lake. The club boathouse is on the left, and the Lakeside building is on the right in the background. (Photographer G.T. Rabineau.)

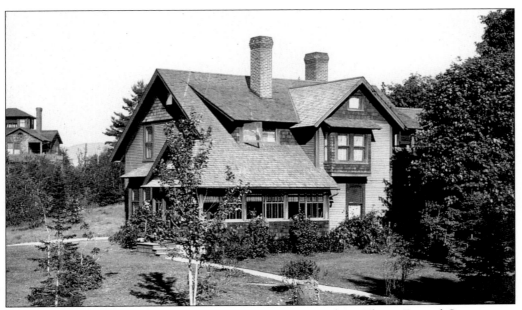

The Lake Placid Club had many cottages for rent to its members. This is Ejwood Cottage as it was *c*. 1920. (Photographer Irving L. Stedman.)

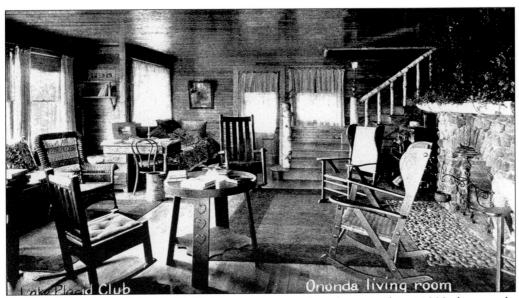

Living quarters at the Lake Placid Club were quite casual, as shown in this *c*. 1900 photograph. Furnishings were simple and sometimes rustic. This cottage was called Ononda. Club cottages were rented by the day, week, month, or entire season.

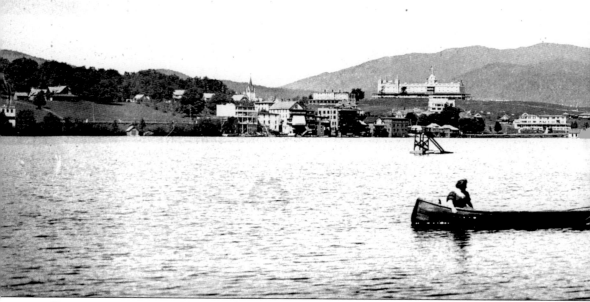

P. A. 25533 Stevens House & Mirror Lake, Adirondack Mts., N. Y.

Canoeists are seen on Mirror Lake at the Lake Placid Club c. 1905. The club's Lakeside

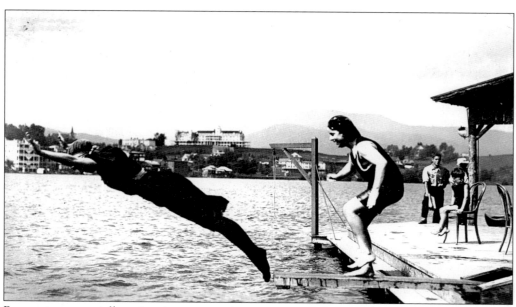

Recreation, especially swimming, was an important summer activity at the Lake Placid Club. These girls are having fun at the club's Mirror Lake boathouse c. 1915. The Stevens House hotel is seen on Signal Hill in the distance. (Photographer Irving L. Stedman.)

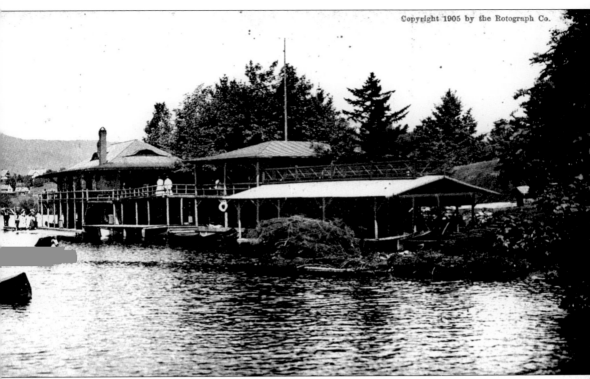

boathouse is on the right. (Rotograph Company, New York City.)

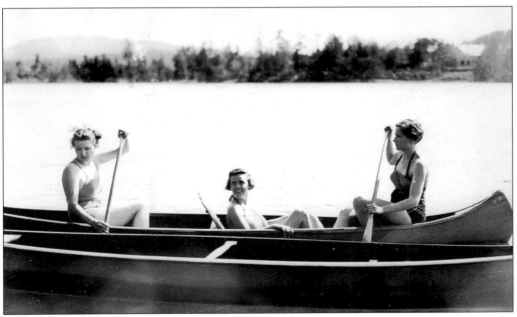

Three young ladies start a canoe trip on Mirror Lake in 1936. They were staying at the Lake Placid Club to represent their Cornell University sorority team at a swimming competition.

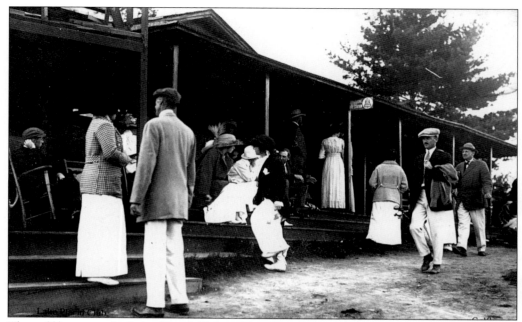

The golf house at the Lake Placid Club was bustling with activity on the day this photograph was taken *c.* 1910. One might have had to wait quite a while for a tee-off time on a nice summer day. (Photographers Stedman & Lockwood.)

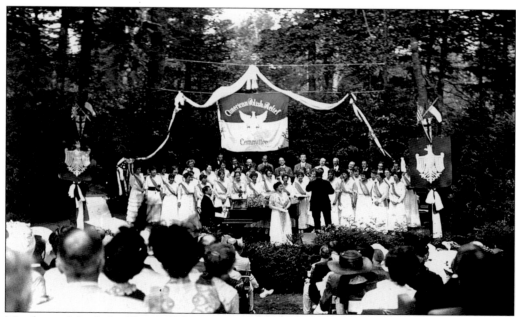

Members of the Lake Placid Club enjoy an outdoor concert, probably at the Arden Theatre, *c.* 1917. The concert was given possibly to raise money for the American Polish Relief Committee. (Photographer Irving L. Stedman.)

# *Four*
# WINTER SPORTS
# AT LAKE PLACID

Two tables of card players are seen "cutting ice" in this January 27, 1906 photograph. Behind them is a team of men and horses cutting blocks of ice from Mirror Lake. This was a large group of people, horses, and dogs to assemble on a frozen lake for a bit of photographic humor.

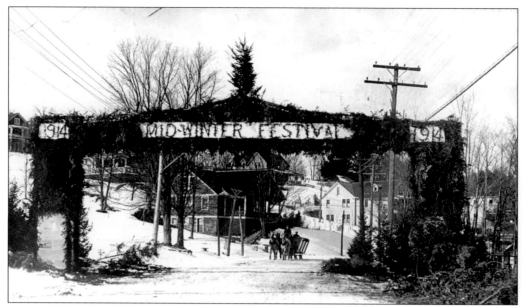

In 1914, the village held its Mid-Winter Festival. The whole village participated in various winter events. This welcoming arch was constructed of ice, wooden poles, and evergreen foliage. Large winter events of this kind were seldom held in Lake Placid, unlike in the village of Saranac Lake. (Photographer Irving L. Stedman.)

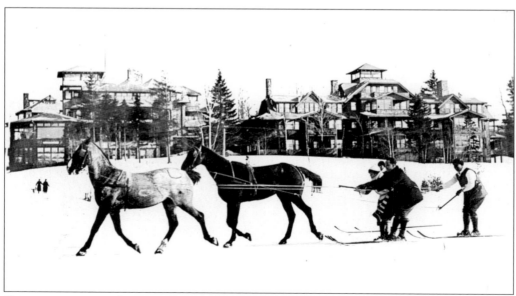

Skijoring was a popular sport at the Lake Placid Club. The sport had gained a large following in Scandanavian countries. The skiers were pulled by horses and sometimes by automobiles across snow-covered ice.

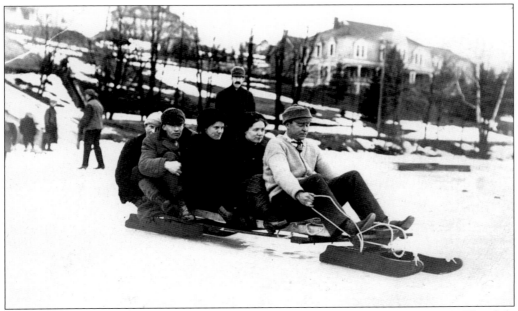

Zooming down a toboggan slide on Signal Hill was a popular winter pastime in 1913. This slide was located near the present Mirror Lake Inn and ended on Mirror Lake. There were at least three other toboggan slides located around Mirror Lake over the years.

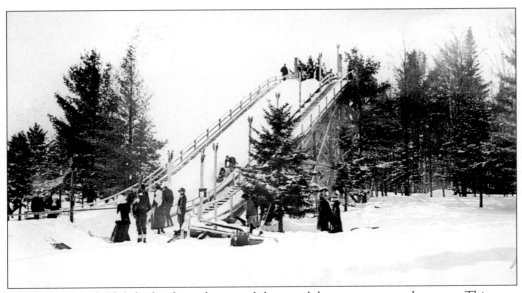

The Lake Placid Club had a few toboggan slides on club property over the years. This one, pictured c. 1915, started near the club's golf house.

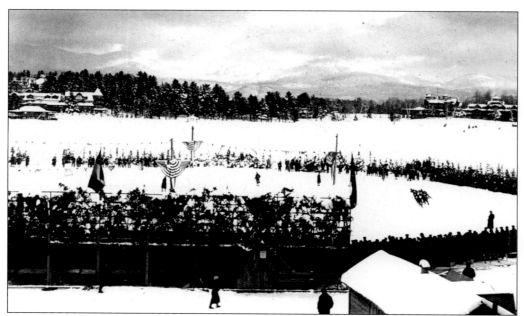

Many international speed skating races, as shown here *c.* 1920, were held on Mirror Lake over the first third of the 20th century. Grandstands were built on the shore for the thousands of attending spectators. Many Lake Placid and Saranac Lake skaters competed and won numerous trophies and medals. (Photographer G.T. Rabineau.)

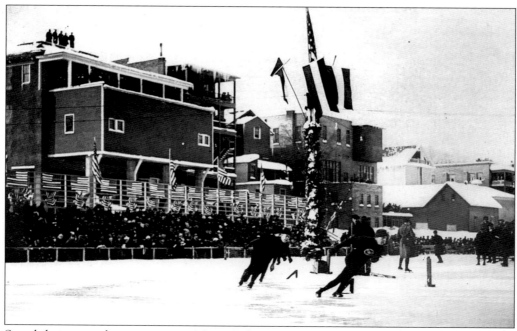

Speed skaters are shown racing on Mirror Lake *c.* 1919. The back of the Happy Hour Theatre is on the left, overlooking the grandstands. The theater was on the opposite side of Main Street from the Hotel Marcy. (Courtesy Mary MacKenzie.)

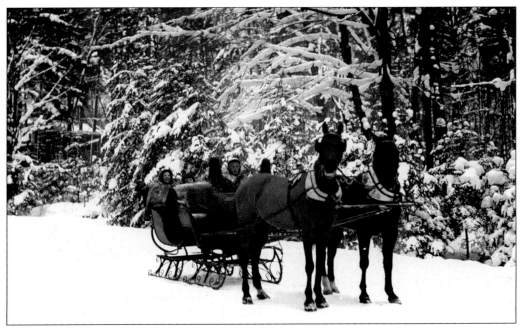

Taking a winter sleigh ride behind a team of horses was an exhilarating experience, as seen in this *c.* 1940 photograph. Most of the time, Lake Placid has ample snow for winter activities like this. Today, people are more likely to take a snowmobile ride. (Photographer Eugene Pierson.)

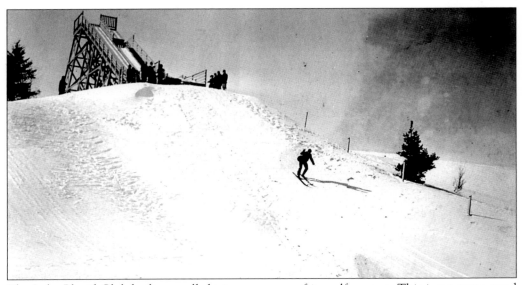

The Lake Placid Club built a small ski jump on one of its golf courses. This jump was a good area for beginners to learn jumping fundamentals, as seen in this *c.* 1920 photograph. (Photographer G.T. Rabineau.)

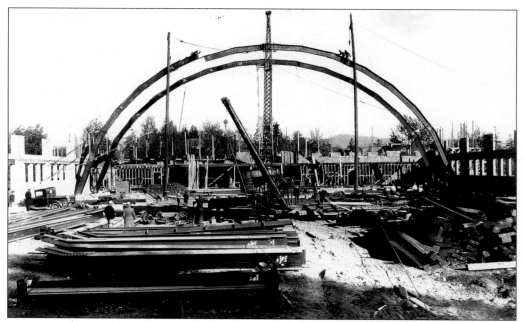

The 1932 Winter Olympic arena is shown during its construction on October 12, 1931. The steel frame was supplied by the Arch Roof Construction Company of New York City. William G. Distin was the Saranac Lake architect for the arena project. This building was the first indoor Winter Olympic ice-skating arena built in the world.

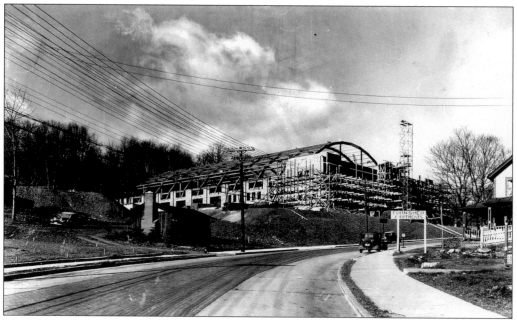

This photograph, taken on October 26, 1931, shows the Olympic Arena in a more complete state of construction. Some $150,000 had been approved by local taxpayers for construction of the building. The arena was ultimately finished a few weeks before the start of the Winter Olympic Games.

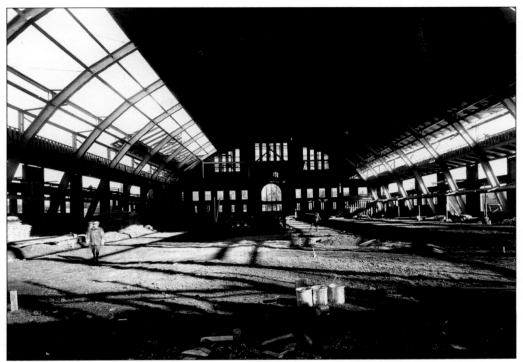

The new arena was about half finished on November 4, 1931. The Arch Roof Construction Company was able to boast of furnishing the steel for the arena in the company's advertising for many years. The arena was dedicated on January 16, 1932.

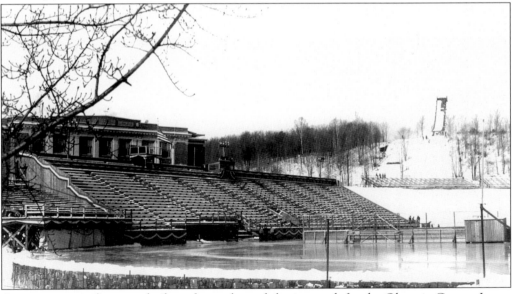

A permanent stadium was built at the oval speed skating track for the Olympic Games. It was used for spectators to observe the opening and closing ceremonies, speed skating races, and ice hockey games. More than 150,000 cubic yards of earth were removed from an adjacent hill and from in front of the high school to build the track and stadium.

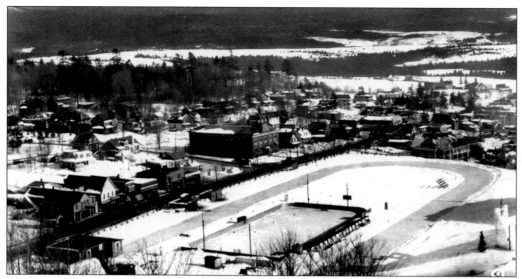

The speed skating track and ice hockey rink are seen in front of the high school *c.* 1935. The large building across Main Street is the North Elba Town Hall. (Photographer Eugene Pierson.)

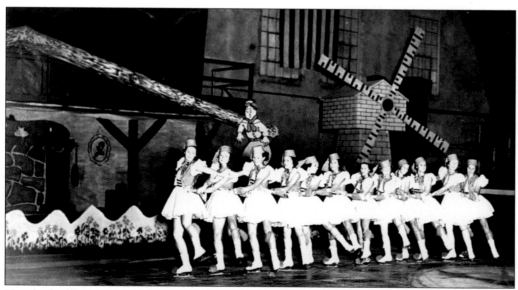

Hundreds of amateur and professional ice-skating shows have been held at the 1932 Olympic Arena over the years. These young girls are seen in a skating production at the arena *c.* 1940.

82

Nineteen-year-old Sonja Henie from Norway won the ladies' figure skating gold medal at the 1932 Winter Olympic Games. She was the favorite after winning a gold medal in 1928. She won again in 1936. (Photographer Roger Moore.)

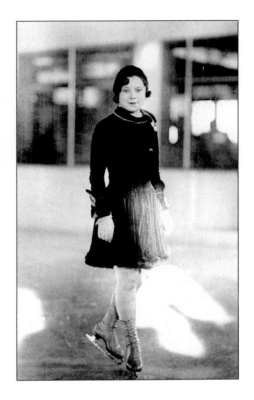

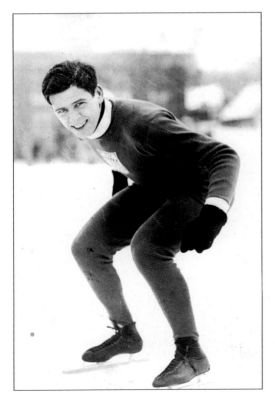

John Amos "Jack" Shea, a 21-year-old Lake Placid native, recited the Olympic Oath for all participants in the 1932 Winter Olympic Games. Thirty-five minutes later, he won the gold medal for 500-meter speed skating, and then won the 1,500-meter race. Jack died just a couple of weeks before his grandson Jimmy won the gold medal for skeleton in the 2002 Winter Olympics at Salt Lake City. (Photographer Roger Moore, courtesy Peter Clark.)

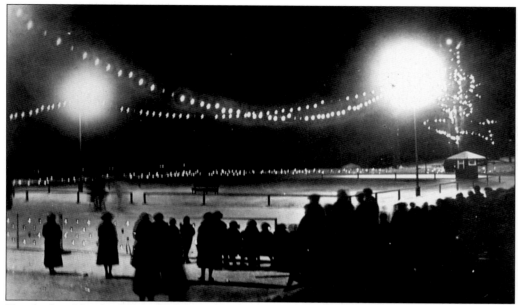

Hundreds of bright lights illuminate a skating rink at the Lake Placid Club as spectators anticipate the upcoming Carnival Night event *c.* 1925. (Courtesy Peter Clark.)

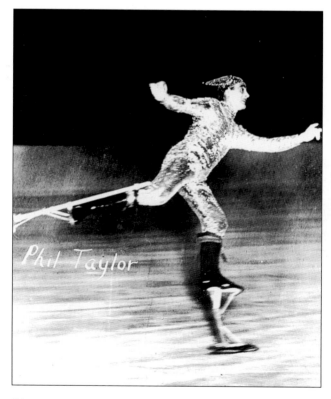

Phil Taylor from England did some crowd-pleasing exhibition skating during the Winter Olympics. He was a noted speed skater, barrel jumper, stilt skater, and all-around showman. His daughter, 11-year-old Megan Taylor, competed in the ladies' figure skating competition. (Photographer Roger Moore, courtesy Peter Clark.)

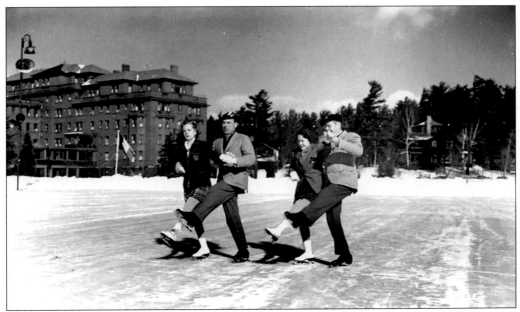

Two couples skate on the Lake Placid Club rinks behind the Agora Suites *c.* 1955. The club flooded its tennis courts to make these rinks. Ice-skating was a very popular winter sport at the club.

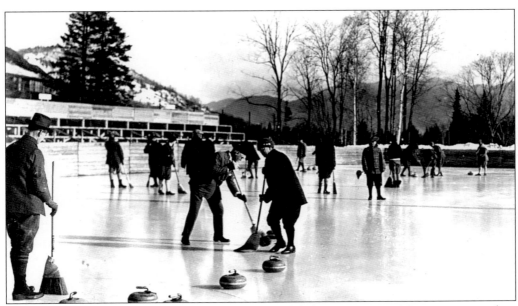

Curling was a winter pastime at the Lake Placid Club for many years. Men are seen curling *c.* 1925 at one of the club's skating rinks. (Courtesy Peter Clark.)

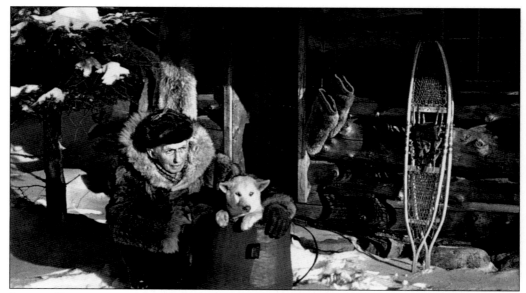

Jacques Suzanne was a world-famous artist and dogsled driver. He raised sled dogs, wolves, horses, and other animals at his "Movie Ranch," which was located on Bear Cub Road. The ranch was often used as a set for making movies. The ranch's small museum was a tourist attraction for many years. (Photographer Dave Jones.)

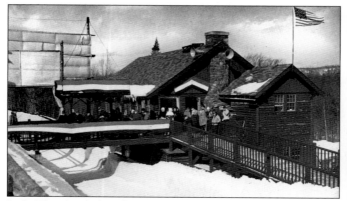 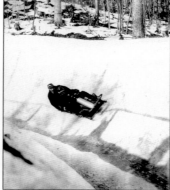

*Left:* The finish line building is loaded with people at the Mount Van Hoevenbergh bobsled course *c.* 1945. A fabric screen protects the frozen track from the warming rays of the sun. This was the only bobsled track in North America for many years. *Right:* Hubert and Curtis Stevens are seen in their gold-medal-winning bobsled run at the 1932 Winter Olympics at Mount Van Hoevenbergh on February 11. The brothers, who grew up in Lake Placid, became hometown celebrities after their win. (Photographer Roger Moore.)

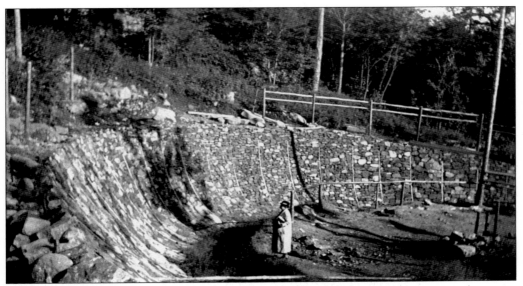

The Mount Van Hoevenbergh bobsled run looks completely different in the summer. A woman surveys a banked curve painstakingly lined with stones *c.* 1935.

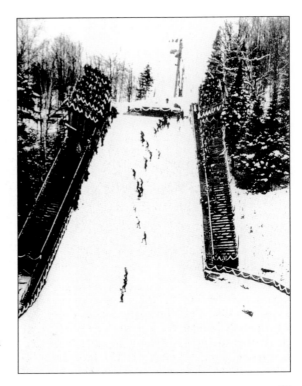

The ski jump at Intervale was constructed originally in 1921 by the Lake Placid Club. Spectator stands and other improvements were added throughout the years. Groomers are seen packing down the snow before a competition in 1932.

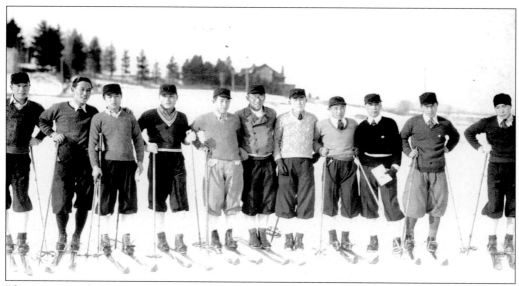

The Japanese ski team was participating in the Winter Olympics at the same time that their country was invading China in an attempt to conquer Asia. The team did not do well, and one Japanese ski jumper crashed into the Intervale grandstand during a practice run. (Photographer Eugene Pierson, courtesy Peter Clark.)

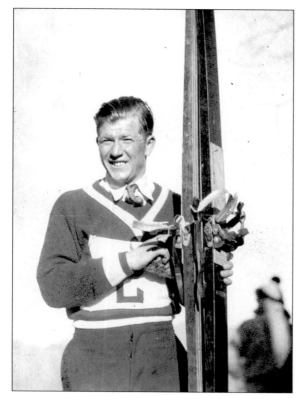

Eighteen-year-old Birger Rudd from Norway won the 70-meter special ski jump gold medal. His Norwegian teammates won the silver and bronze medals. (Photographer Eugene Pierson, courtesy Peter Clark.)

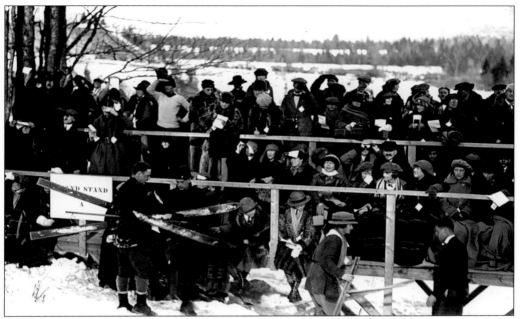

The spectator stands at Intervale are teeming with Lake Placid Club members waiting between ski jump runs *c.* 1928. (Photographer Irving L. Stedman.)

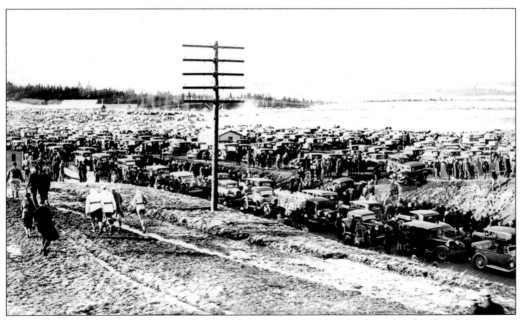

Frozen Intervale farm fields were converted to a vast spectator parking lot for the ski jumps at the 1932 Winter Games. Ticket sales for the games totaled around $94,000, which was far below expected sales. (Photographer Irving L. Stedman, courtesy Peter Clark.)

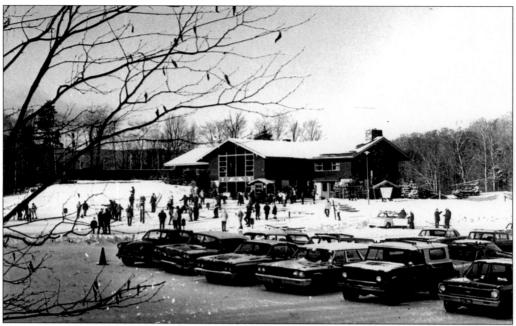

Mount Whitney Ski Center was built and opened in 1937 by the Lake Placid Club. This ski lodge was built in the early 1960s and is seen *c.* 1967. A few years ago, the lodge burned due to an arson fire. The ski hills' future is uncertain at this time.

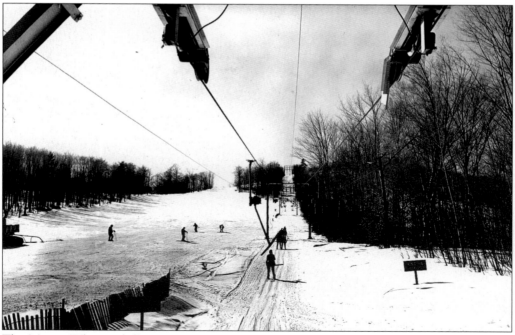

The Mount Whitney hill was not very high, but the slope was a good one on which to learn basic skiing skills. The area has not been used much since the club was closed. This photograph was taken *c.* 1965.

*Five*

# THE CASCADE LAKES

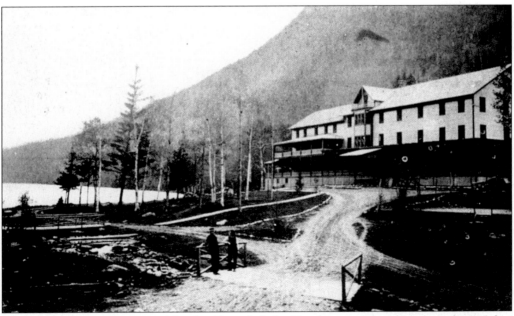

A *c.* 1900 advertising postcard for the Cascade Lake Hotel states, "An elevation of 2,045 feet ensures freedom from hay fever and kindred troubles. Modern equipment throughout. The best trout fishing in the Adirondacks." The hotel was located just outside the North Elba town line and was an important stagecoach stop on the way to Lake Placid and Saranac Lake.

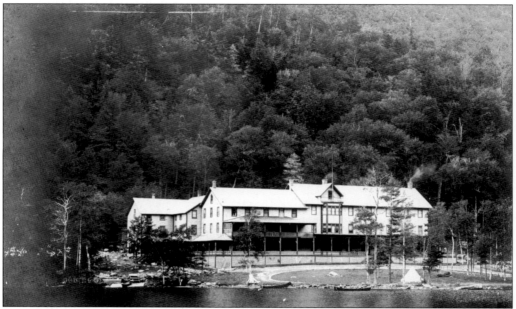

The Cascade Lake Hotel was built by Sidney and Warren Weston in 1878. The hotel's location between Keene and Lake Placid made it a natural place for travelers to stop. A new road had been constructed by the state in 1858 through Cascade Pass.

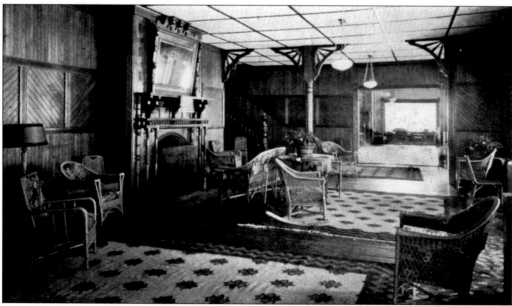

The lounge of the Cascade Clubhouse is seen updated with casual wicker furniture c. 1925. The Lake Placid Club was given the Cascade Lake Hotel and surrounding mountains as a gift in 1923 and was renamed the Cascade Clubhouse.

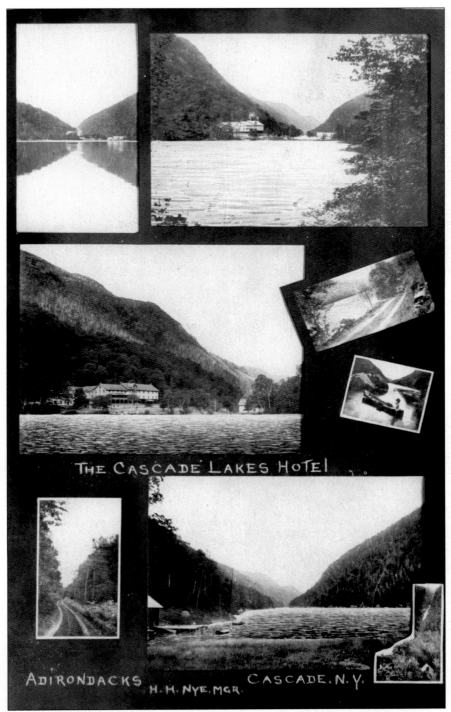

The Cascade Lakes Hotel

Adirondacks    H. H. Nye, Mgr.    Cascade, N. Y.

This artistic postcard from *c.* 1910 combines eight photographs into a collage of the Cascade Hotel. H.H. Nye is listed as manager. The hotel was situated on the isthmus between Lower and Upper Cascade Lake. (Photographer Underwood, Elizabethtown, New York.)

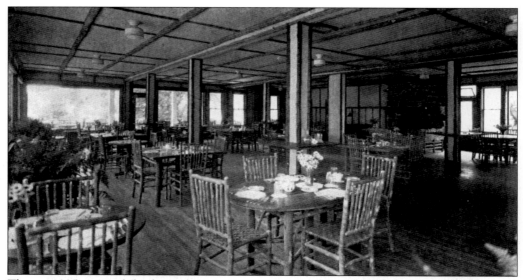

This c. 1925 view of the large dining room at the Cascade Clubhouse shows rustic hickory tables and chairs. Large plate-glass windows gave the guests a wonderful view of the lakes and mountains.

Hotel guests pose for the camera next to a guide boat on Lower Cascade Lake c. 1890. Pitchoff Mountain starts abruptly on the left shore. The gentlemen are wearing suits and straw hats. The

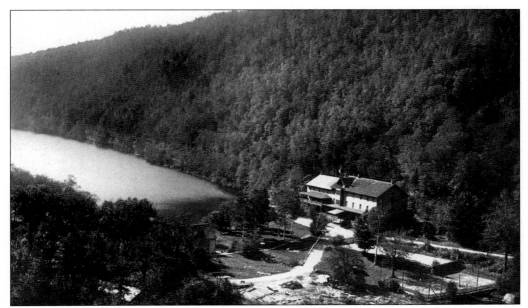

The Cascade Lake Hotel is seen c. 1920 from Cascade Mountain. Around 1860, a giant landslide divided one-and-a-half-mile-long Long Lake into two lakes. The lakes were then renamed Edmund's Ponds. Later still, they were renamed Upper and Lower Cascade Lake. (Photographer G.T. Rabineau.)

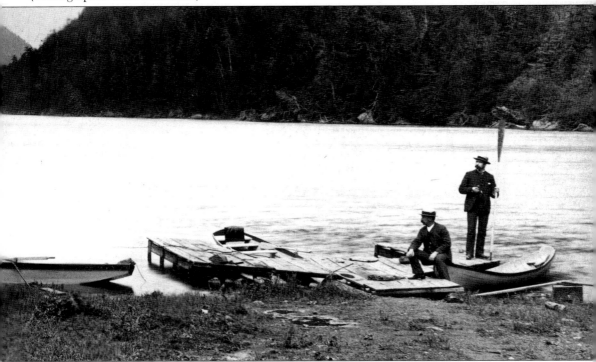

stagecoach road (Route 73) to Keene is in the woods on the left. (Photographer Baldwin, Plattsburgh, New York.)

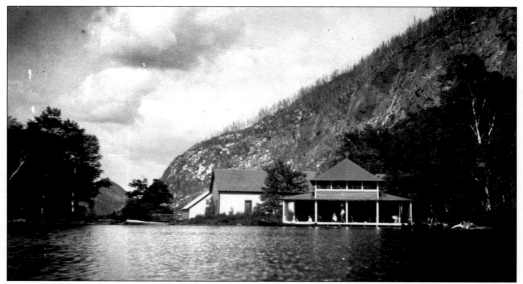

The hotel had numerous small boats for guests to enjoy. The boathouses, shown *c.* 1908, were conveniently located between the lower and upper lakes near the hotel. There was an almost constant breeze through the mountain pass to cool hot summer air. In winter, the pass was an icy, windblown place for travelers to negotiate, as it still is for today's travelers.

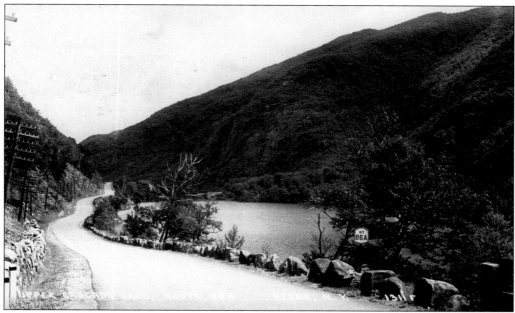

State Route 86A (now Route 73) is shown above Upper Cascade Lake *c.* 1940. Since the road was built by the state in 1858, it has been the route between Keene and Lake Placid. (Eastern Illustrating Company, Belfast, Maine.)

# Six

# NORTH ELBA VIEWS

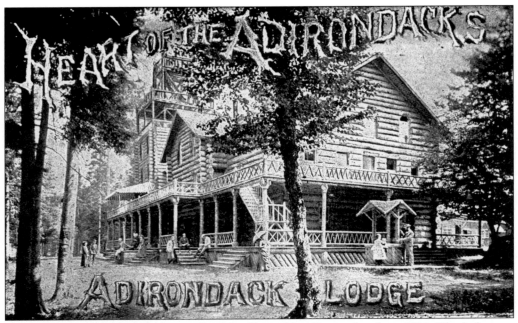

The original Adirondack Lodge was built by Henry Van Hoevenbergh in 1880. The lodge was professed to be the largest log building in the country. The massive rustic building burned to the ground during a forest fire in 1903. The lodge was owned by the Lake Placid Club when the building met its fiery fate. Metal valuables were thrown into nearby Clear Lake so they would not be consumed by the fire.

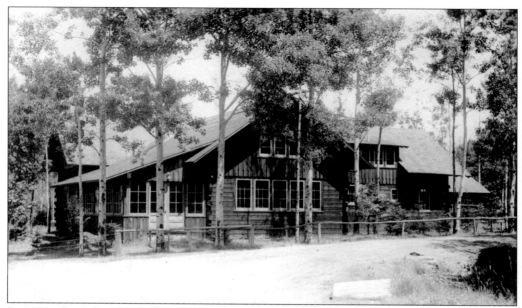

In 1928, the Lake Placid Club erected a much smaller building to give members a lodge and staging area for climbing the nearby high peaks. The club called the building Adirondack Loj, using Melvil Dewey's Simpler Speling (*sic*) system. Dewey founded the club in 1895. The building is still in use today by the Adirondack Mountain Club. This photograph was taken *c.* 1935.

The name of Clear Lake was later changed to Heart Lake. This large open camp or lean-to was constructed at Heart Lake to provide rustic accommodations for campers. Heart Lake sits at the foot of Mount Jo, which Henry Van Hoevenbergh named for a woman he loved.

Heart Lake and Adirondack Loj sit at the northern gateway to the High Peaks region. If you take a two-mile hike to Marcy Dam, you are near many of the highest Adirondack Mountains.

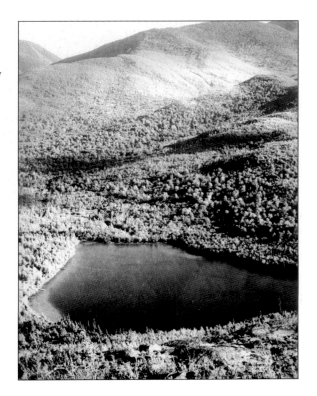

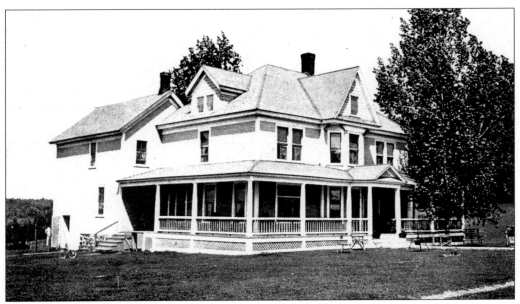

Mountain View Farm was built by Robert Ames in 1903. The site was previously the location of a popular stagecoach inn called the Mountain View House. The property was later called Olympic Heights and is still located on Route 73, near Country Club Road.

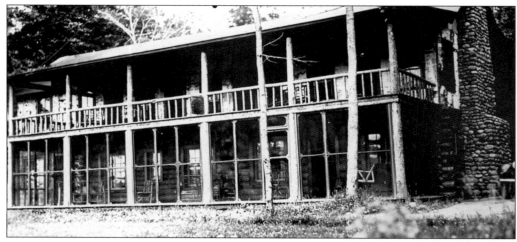

The Bear Cub was a nightclub and restaurant located south of Lake Placid village on Bear Cub Road. The club seen in this *c.* 1927 photograph was very rustic. In the 1920s, the log building was used as a movie set. The property later became Bear Cub Camp, owned by Fred Fortune. (Photographer G.T. Rabineau.)

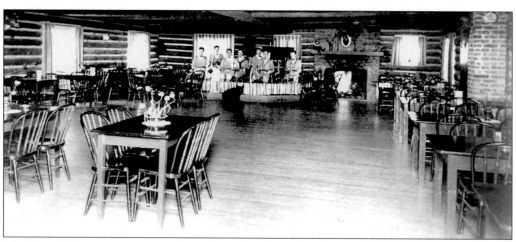

The Bear Cub was open seasonally and employed small orchestras to play live dance music. A 1929 advertisement states, "Lake Placid's Unique Dining and Dancing Institution, with the Snappiest Entertaining Dance Band This Favorite Spot Has Ever Seen—Omar Perkins and his Orchestra." (Photographer G.T. Rabineau.)

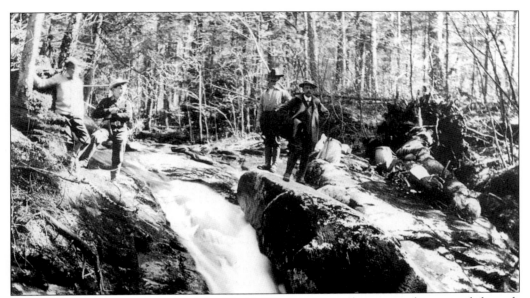

Four hikers cross a small branch of the Chubb River *c.* 1915. They were taking a trail through the forest to Moose Pond, which is about eight miles southwest of Lake Placid village. (Photographer Irving L. Stedman.)

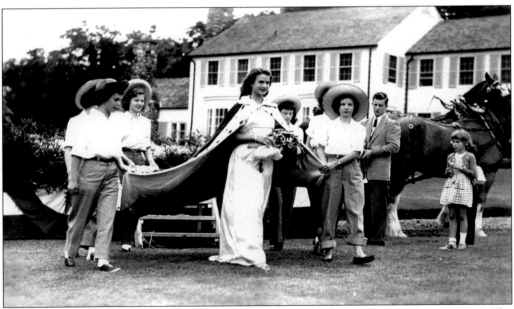

Children are dressed for a parade or party at Henry Uihlein's Heaven Hill Farm *c.* 1955. The house in the background is the old Horatio Hinckley farmhouse that was remodeled and enlarged by Uihlein into the edifice it is today. It is located on Bear Cub Road and is one of the oldest buildings surviving in the town of North Elba. The farm is a proposed location for the National Sports Academy, located in Lake Placid.

A young woman peers at the gravestone of the abolitionist John Brown at the Brown farm *c.* 1878. The site is a couple of miles south of Lake Placid village. She is leaning on a wooden box that protected the stone from souvenir hunters. This tombstone was originally that of his grandfather, who was laid to rest in Canton, Connecticut. John Brown moved the stone to North Elba before his death. (Photographer S.R. Stoddard, Glens Falls, New York.)

John Brown lived on a rented farm in North Elba from 1849 until 1851 and then moved his family to Ohio. They returned to North Elba in 1855 and moved into this farmhouse that had been partially completed for him by relatives. Brown spent little time at the farm and was hanged on December 2, 1859, at Charlestown, Virginia.

In 1896, a group of people donated money to buy the John Brown farm so that it could become a state historic site open to the public. A stone monument was erected to thank the generous donors. This photograph of a young woman next to the monument was taken on August 8, 1898, during her visit to Lake Placid.

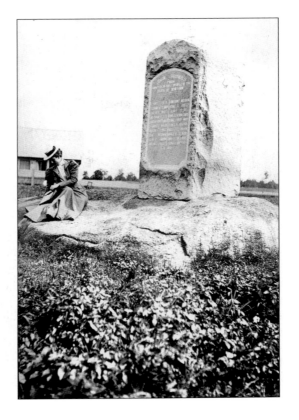

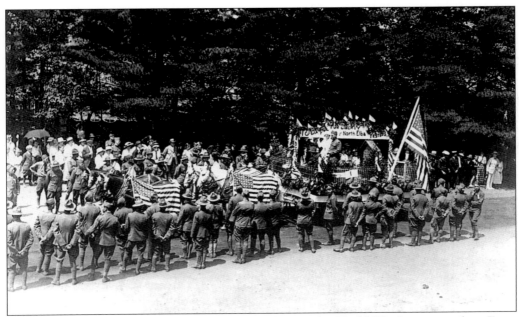

In July 1919, the town held a welcome home celebration for World War I returnees from Essex County. The parade float pictured is from North Elba and depicts the John Brown farm.

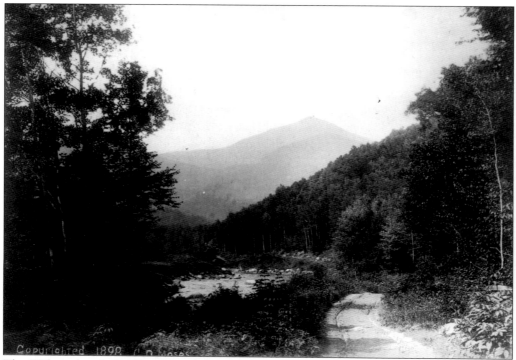

The Wilmington-Lake Placid Road (Route 86) is seen in 1898. The road at that time was a rutted single-lane dirt highway for horse and wagon. Whiteface Mountain is seen in the distance. (Photographer Chester D. Moses, courtesy Mary MacKenzie.)

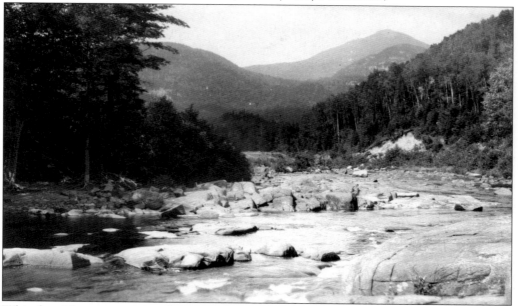

Whiteface Mountain is seen above a rocky section of the West Branch of the Ausable River c. 1930. This view is one of the most photographed in the Adirondacks and has been a favorite area for trout fisherman for the last 150 years. (Photographer Irving L. Stedman.)

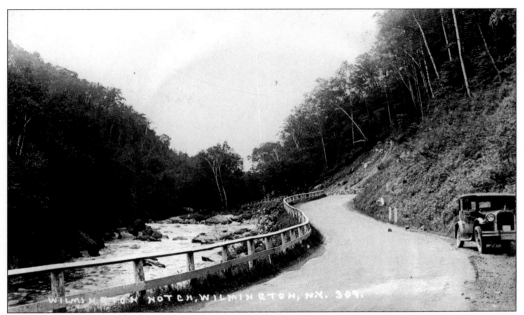

An automobile sits on the edge of the Wilmington Notch Drive just outside the North Elba township boundary c. 1930. This highway (now Route 86) between Wilmington and Lake Placid is one of the most scenic in the Adirondacks. (Eastern Illustrating Company, Belfast, Maine.)

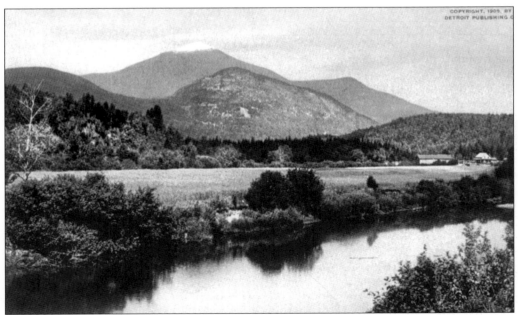

Whiteface Mountain is seen in the distance from the West Branch of the Ausable River c. 1900. This view is a couple of miles from Lake Placid village along the Riverside Drive, now also known as the 10th Mountain Division Highway. (Detroit Publishing Company, Detroit, Michigan.)

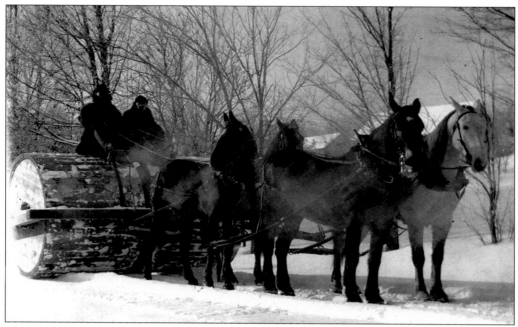

The town of North Elba's snow roller is seen *c.* 1900. The roads filled with snow were rolled to compact the snow and make them suitable for horse and sleigh use. Later, when motor vehicles came into use, snowplows were used to clear the roads. (Courtesy Mary MacKenzie.)

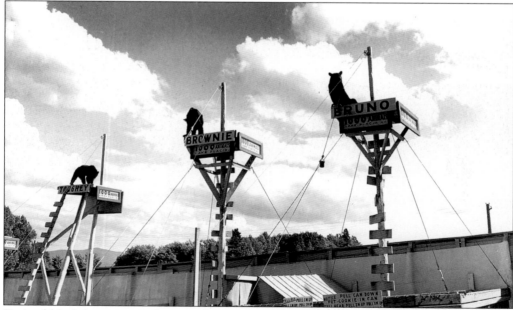

Trained black bears sit on their perches at 1000 Animals Theme Park *c.* 1950. People would fill a can on a rope with special animal cookies and would yell, "Pull 'em up!" The bear would then pull the rope up to get his treat. This family-run attraction was originally called the Sterling Alaska Silver Fox Farm and was located at the intersection of Whiteface Inn Road and Saranac Avenue.

# Seven

# PONTIAC BAY
## ON LAKE FLOWER

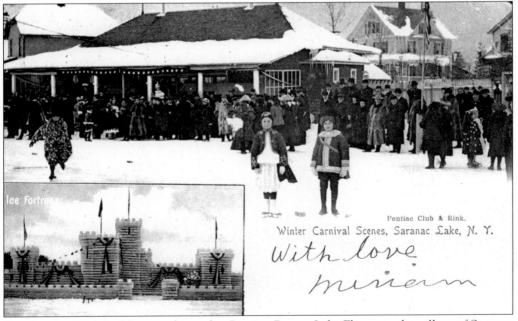

The Pontiac Club building was located at Pontiac Bay on Lake Flower in the village of Saranac Lake. Ice-skating events were a popular winter pastime in the village. Many championship speed skating events were held there throughout the years. (Harding and Gray, Saranac Lake.)

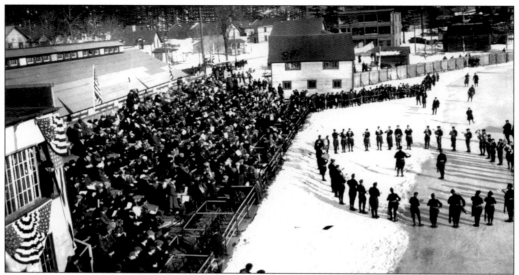

A band plays in front of the Pontiac Rink grandstand *c.* 1925. The crowd was anticipating the exciting speed skating races that would soon begin. (Carrington Company, Saranac Lake.)

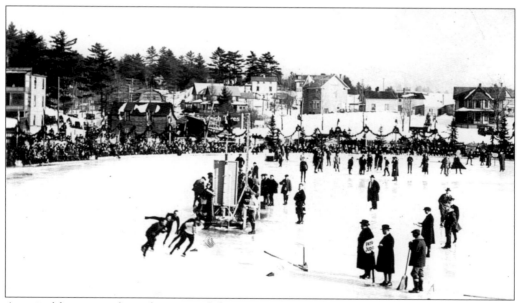

A typical large crowd watches a speed skating race *c.* 1925. These were well-organized events, and many were sanctioned by the International Skating Union of America. The outdoor rink needed constant maintenance to remove snow and keep the surface smooth. (Photographer G.T. Rabineau, Lake Placid.)

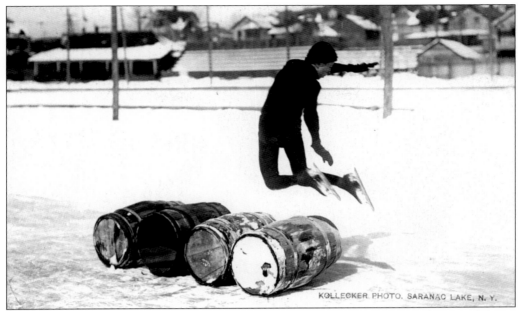

Ed Lamy, a Saranac Lake resident, is seen jumping barrels at the Pontiac Rink c. 1925. Lamy had jumped as many as 12 barrels at a time. His skating and jumping ability was legendary in the area. (Photographer William Kollecker, Saranac Lake.)

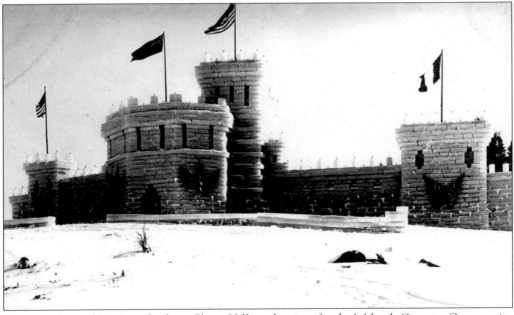

The ice palace of 1911 was built on Slater Hill on the site of today's North Country Community College administration building. This site was also used in 1909, 1913, and 1920 for ice castles.

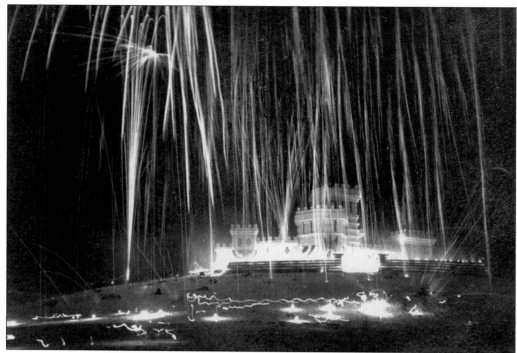

This scene of "storming the palace" was done at night with fireworks and many lights. The photograph shows the festivities on Slater Hill in 1911.

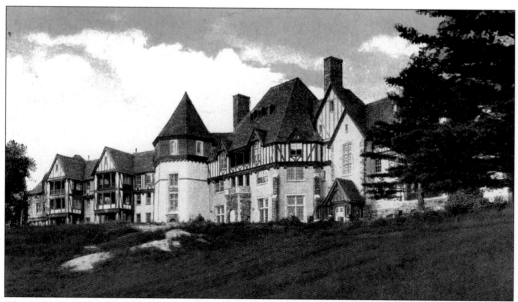

The National Vaudeville Artists Lodge was built in 1930 to accommodate members who had tuberculosis. The name was later changed to Will Rogers Memorial Hospital. After a few failed attempts at adaptive reuse, the building has been transformed into attractive senior apartments. (C.W. Hughes & Company, Mechanicville, New York.)

# *Eight*

# RAY BROOK

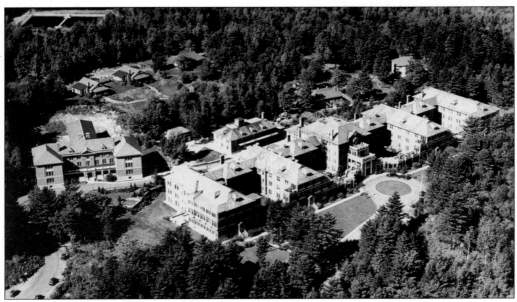

The New York State Hospital for the Treatment of Incipient Pulmonary Tuberculosis was built in 1904 and enlarged, as shown in 1910. The hamlet of Ray Brook is located between Saranac Lake and Lake Placid.

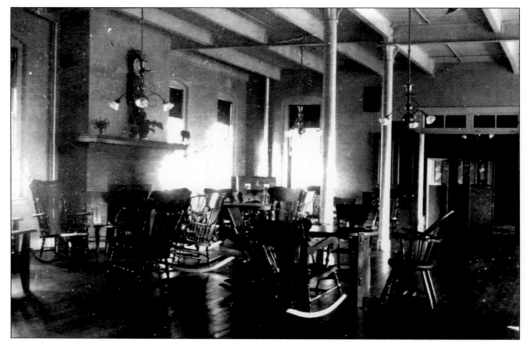

The tuberculosis hospital was generally known as Ray Brook Sanatorium. This hospital interior photo postcard was taken c. 1905. A message from a tuberculosis patient reads, "This is a picture of the solarium, where we spend an hour each evening, the only piano is not in the picture. I am feeling unusually well, only I lost a pound last week—my first loss."

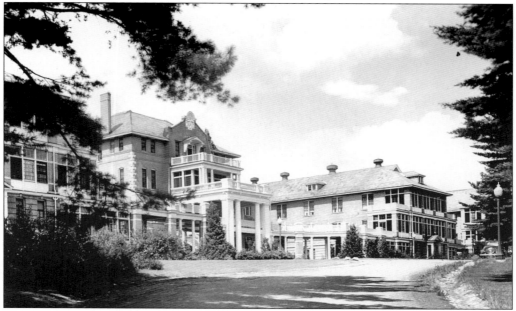

In 1946, the hospital name was changed to Ray Brook State Tuberculosis Hospital. The facility was built on a 529-acre site near the Ray Brook, a small river. The hospital today is a state prison and is known as the Adirondack Correctional Facility.

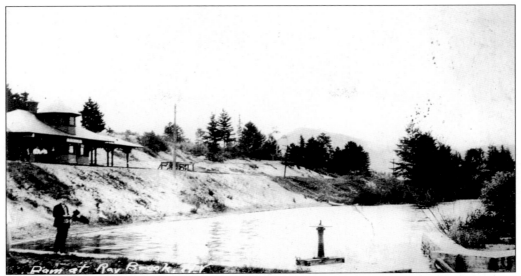

A man is shown standing on the Ray Brook dam *c*. 1925. The Ray Brook station of the Delaware & Hudson Railroad sits on the bank above him. This station was later replaced by a more modern one.

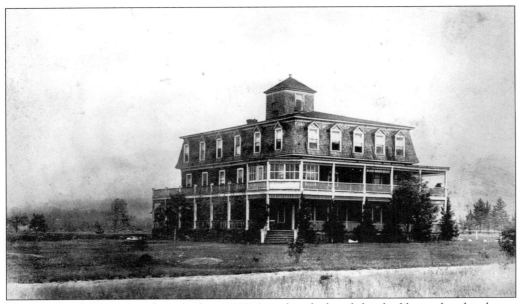

The Ray Brook House hotel was built *c*. 1908. It replaced a hotel that had burned and is shown *c*. 1920. The hotel was used by travelers and relatives visiting patients at the nearby tuberculosis hospital. The building was razed *c*. 1953. New York State government buildings occupy the site today. (Eastern Illustrating Company, Belfast, Maine.)

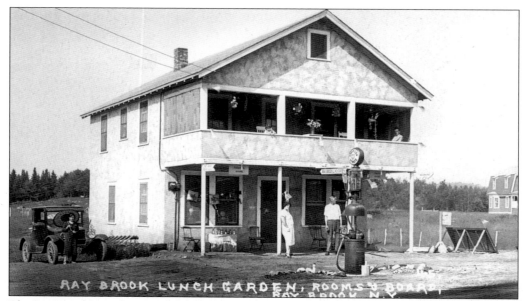

The Ray Brook Lunch Garden, seen *c.* 1928, was all set to sell motorists everything they required. It sold American Strate gasoline, hot dogs, and souvenirs, and also rented furnished rooms.

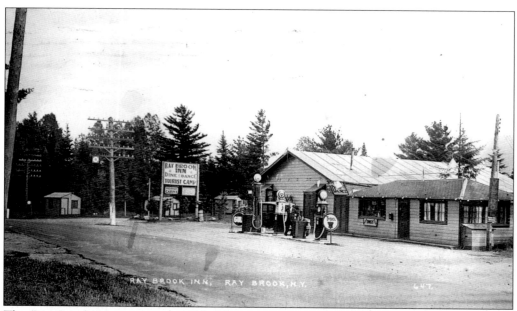

The Ray Brook Inn is seen *c.* 1927. This tourist camp catered to motorists and offered a multitude of amenities to them. It sold gasoline and oil. It also rented out rustic cabins and had a dance hall. A restaurant served "deluxe dinners."

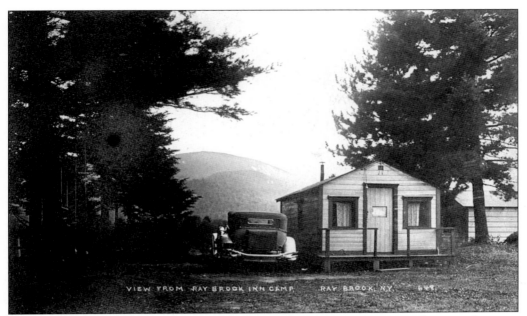

Many people who traveled by automobile did not want to stay in any one location for more than a few days, as they had prior to 1910. Cabin colonies catering to motorists sprang up overnight. This quickly doomed many large hotels. The owners of this expensive convertible were staying c. 1932 in a small cabin at the Ray Brook Inn. (Eastern Illustrating Company, Belfast, Maine.)

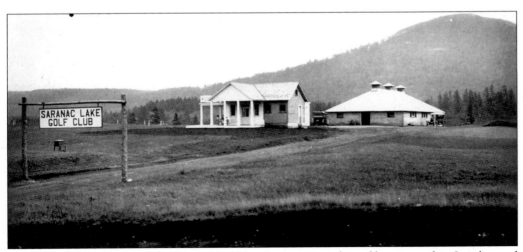

The Saranac Lake Golf Club, shown c. 1930, remains a popular golf course today. It is located just east of Ray Brook. (Photographer G.T. Rabineau.)

White Birch Lodge, at Duprey's Log Cabins in Ray Brook, had a fireplace and chimney for the cook stove. Duprey's rented many rustic cabins of various sizes. (Eastern Illustrating Company, Belfast, Maine.)

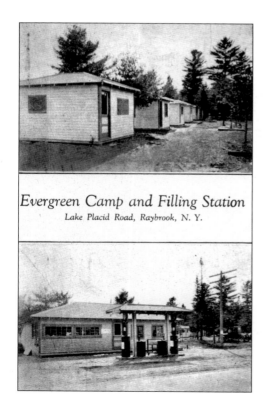

The Evergreen Camp and Filling Station is shown c. 1925. A row of small inexpensive cabins awaits the weary traveler at the roadside enterprise. (Santway Photo-Craft, Watertown, New York.)

# Nine
# WHITEFACE MOUNTAIN

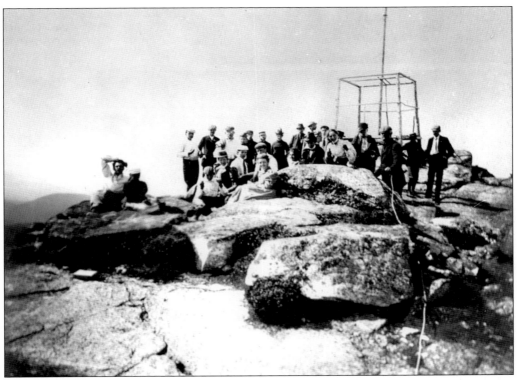

A group of hardy Lake Placid Club members is seen at the summit of Whiteface Mountain in 1898. The group was led by club secretary Harry Wade Hicks. The wooden structure behind them is possibly a signal tower erected by Verplanck Colvin. Colvin was superintendent of the State of New York Adirondack Survey. The agency conducted a land survey of the Adirondack Park in the late 1800s.

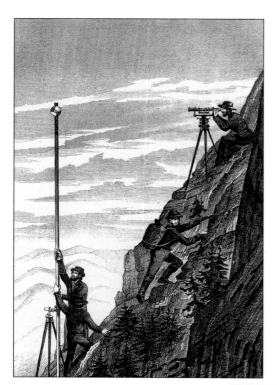

A drawing by Verplanck Colvin shows a crew using the spirit-level and graduated rod method of determining the height of Whiteface Mountain in the 1870s. Later, the more accurate barometer was used to determine height above sea level.

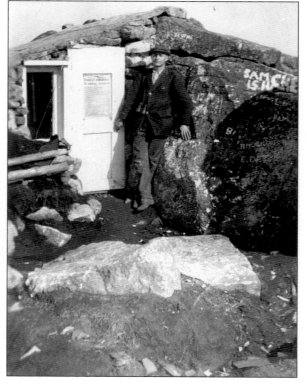

A small shack made of rock and concrete, as seen c. 1925, was constructed at the summit of Whiteface Mountain to give shelter from wind and rain to forest fire observers. Later, the Summit House was built on the site of the shack c. 1935. The fire observers actually lived in a cabin at the 4,000-foot level of the mountain. (Photographer G.T. Rabineau.)

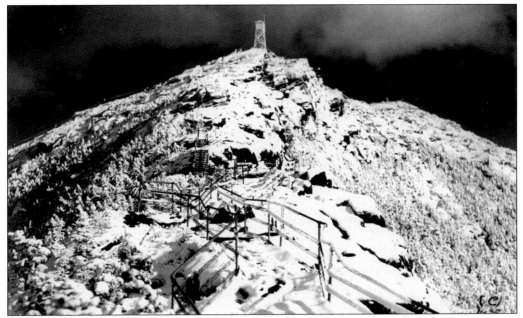

The old fire tower at the Whiteface Mountain summit is seen *c.* 1940. The tower was erected in 1919 and removed in 1971. Whiteface is covered in a layer of new snow. Late-spring snows can sometimes be seen on high peak summits as late as early June.

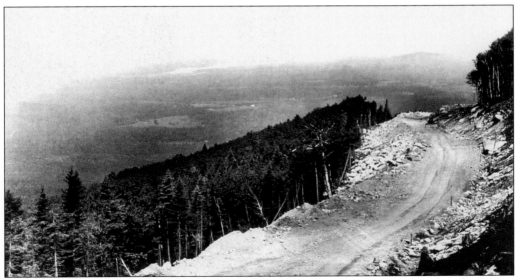

A paved road seven miles long was completed from Wilmington to the top of Whiteface Mountain in 1935. The *c.* 1934 photograph was taken during construction of the Whiteface Mountain Memorial Highway, which is still the only road to the top of a high peak in the Adirondack Park. Due to stringent state laws, it will probably be the last.

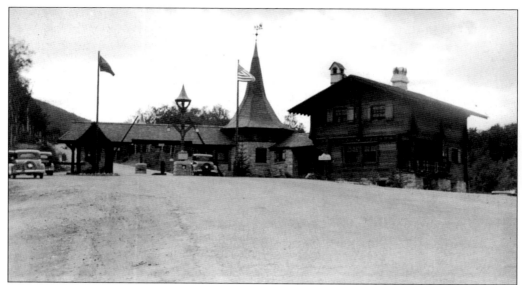

A rustic chalet-style tollhouse was constructed at the beginning of the new Memorial Highway near Wilmington, as seen in this c. 1936 photograph.

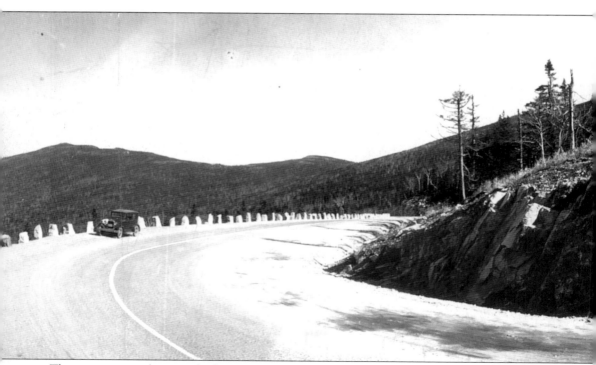

This panoramic photograph shows the hairpin turn on the Whiteface Mountain Memorial Highway c. 1936. Pull-off areas give vehicles safe areas to park, so passengers can enjoy the

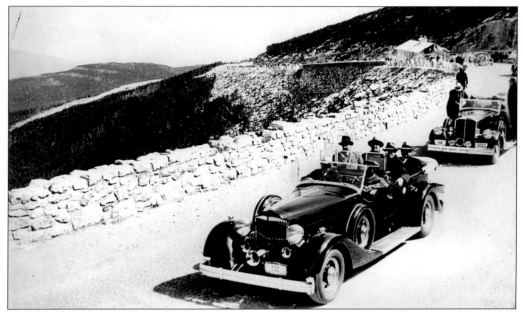

Pres. Franklin D. Roosevelt is shown being driven to the top of the newly completed Whiteface Mountain Memorial Highway on September 14, 1935. Roosevelt was there to speak at the dedication of the highway. He was New York State governor when construction was started a few years earlier.

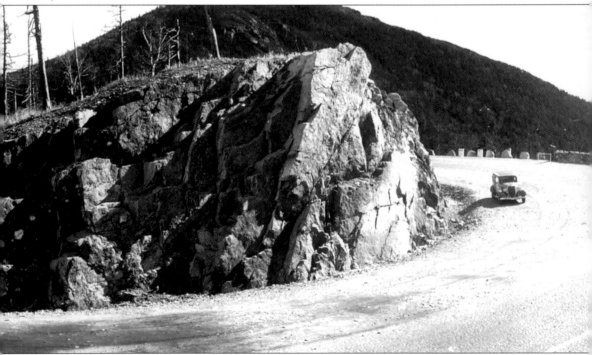

beautiful views.

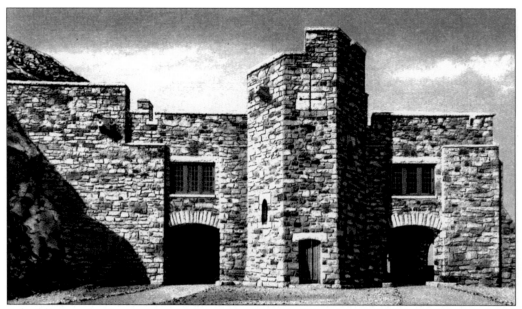

A building made of stone was constructed at the end of the Memorial Highway. The castlelike structure still houses a small restaurant, gift shop, and restroom facilities. (C.W. Hughes, Mechanicville, New York.)

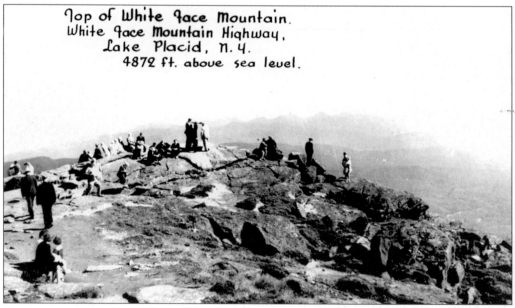

Spectators are seen here enjoying the view from the top of Whiteface Mountain c. 1955. The summit is 4,872 feet above sea level, and about 3,000 feet above Placid Lake. This is probably the only Adirondack high peak summit where you might find a man dressed in a suit. (Photographer Barbeau, Oswego, New York.)

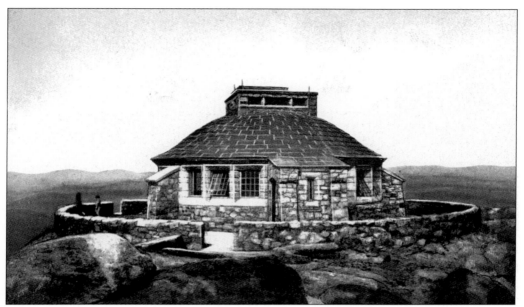

After the Memorial Highway was completed, an elevator terminal was constructed in the new Summit House at the top of Whiteface Mountain. The base of the elevator is reached by a tunnel drilled horizontally into the solid rock. At the end of the tunnel, the elevator rises to the summit. (Albertype Company, New York City.)

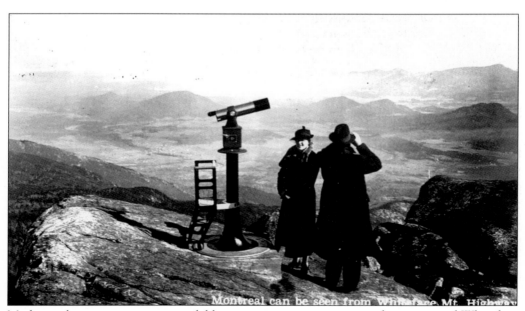

Montreal can be seen from Whiteface Mt. Highway

Modern telescopes were now available to tourists motoring up to the summit of Whiteface Mountain. The caption for this c. 1937 photo postcard reads, "Montreal can be seen from Whiteface Mt. Highway." ($5.00 Photo Company, Canton, New York.)

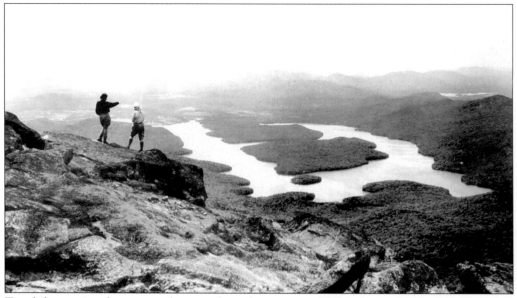

Two hikers enjoy the spectacular view from the summit of Whiteface c. 1940. On a clear day, one can see 125 miles in the distance, as there are no other high peaks in the immediate vicinity to obstruct the view. (Photographer Roger Moore.)

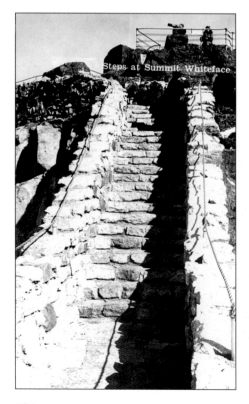

The mountain summit can be reached by a foot trail that starts at the castle building. This c. 1936 photograph shows stone steps at the top, which can be used to start the descent to the castle. ($5.00 Photo Company, Canton, New York.)

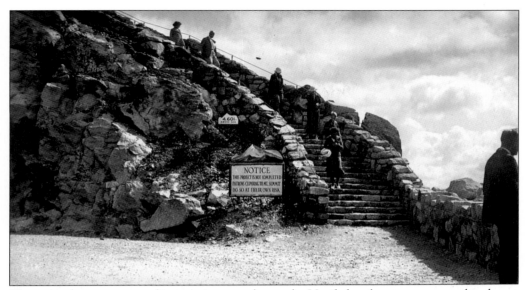

These are the stone steps that terminate at the castle. Until the elevator was completed, one had to use the trail to reach the summit.

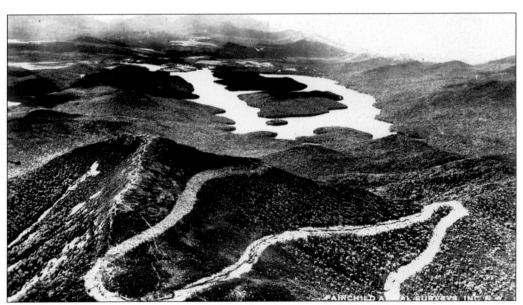

The Memorial Highway was still under construction when this aerial photograph was taken c. 1934. Placid Lake is seen in the distance. (Fairchild Aerial Surveys Inc., New York City.)

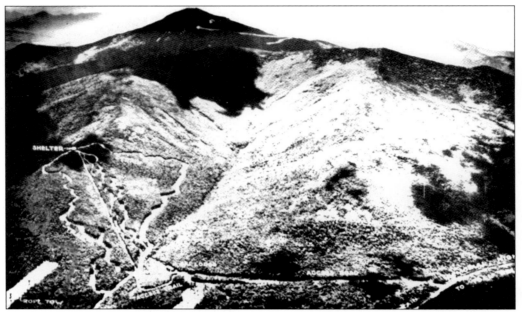

The first ski center constructed at Whiteface Mountain was built on a shoulder of the mountain called Marble Mountain. The center officially opened in 1950. An access road was built to connect the ski center to the Whiteface Mountain Memorial Highway.

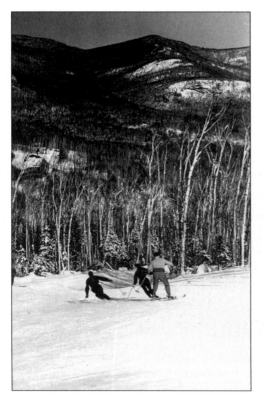

A Marble Mountain ski trail is shown in this c. 1952 photograph. Marble Mountain was abandoned as a ski center after a few years of use due to poor snow conditions. A building is still in use by the Atmospheric Science Research Center. Weather readings are taken at an atmospheric monitoring tower on top of Whiteface near the Summit House.

The T-bar lift at Marble Mountain was the way to travel up the hill in 1950. Today, many skiers are used to luxurious heated gondola lifts.

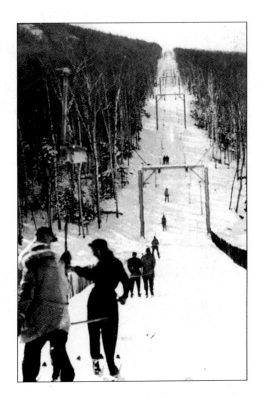

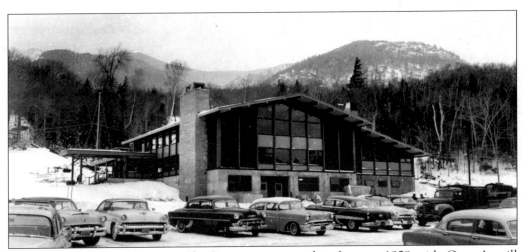

The new Whiteface Mountain Ski Center was opened in January 1958 with Gov. Averill Harriman officiating at the opening ceremonies. The base lodge, shown c. 1958, was renovated and enlarged for the 1980 Winter Olympics, held at Lake Placid. (Photographer David Jones.)

# BIBLIOGRAPHY

Ackerman, D. *Placid Lake: A Centennial History 1893–1993*. Lake Placid, New York: the Shore Owners' Association of Lake Placid Inc., 1993.

De Sormo, M. *The Heydays of the Adirondacks*. Saranac Lake, New York: Adirondack Yesteryears Inc., 1974.

De Sormo, M. *Told Around the Campfire: Henry Van Hoevenbergh*. Saranac Lake, New York: Adirondack Yesteryears Inc., 1967.

Donaldson, A. *A History of the Adirondacks*. New York, New York: the Century Company, 1921.

Hayes, A. *Lake Placid: The Switzerland of America*. Lake Placid, New York: Arthur Hayes, 1946.

Hotaling, M. *Saranac Lake Winter Carnival 1997: The Origins of Saranac Lake's Winter Carnival*. Saranac Lake, New York: Adirondack Daily Enterprise, 1997.

MacKenzie, M. *Lake Placid and North Elba: A History 1800–2000*. Lake Placid, New York: The Bookstore Plus, 2002.

Martin, P. *Adirondack Golf Courses: Past and Present*. Lake Placid, New York: Adirondack Golf, 1987.

Ortloff, G. *Lake Placid: The Olympic Years 1932–1980*. Lake Placid, New York: Macromedia Inc., 1976.

Shore Owners Association of Lake Placid. *S.O.A. Handbook*. Lake Placid, New York: the Shore Owners Association of Lake Placid, 1919.